California Impressionists

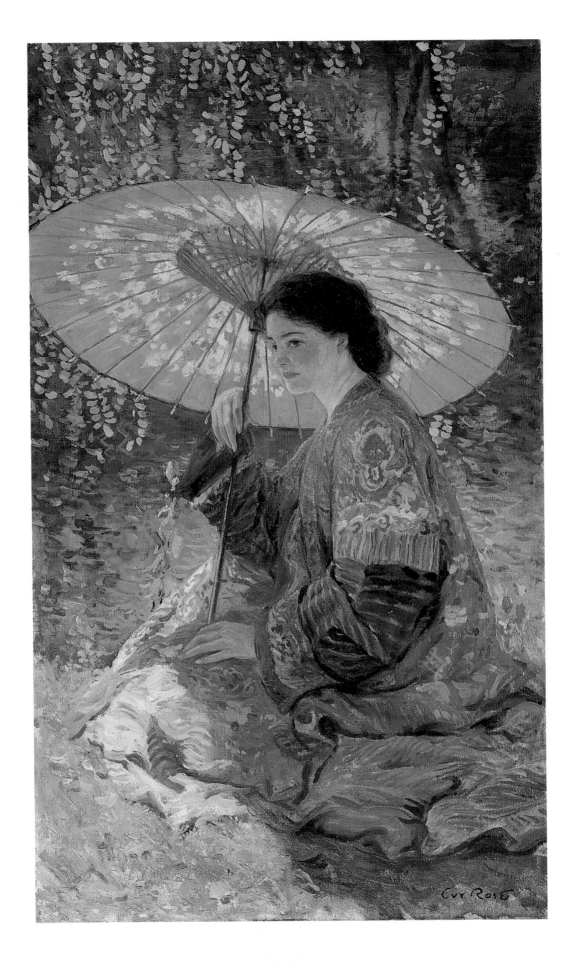

California Impressionists

Text by
SUSAN LANDAUER

with additional essays by

DONALD D. KEYES
JEAN STERN

*A presentation of the Atlanta Committee for
The Olympic Games (ACOG) Cultural Olympiad*

The *Irvine*
Museum

CULTURAL
OLYMPIAD

Atlanta 1996

GEORGIA
MUSEUM
OF · ART

Cover: Catalogue Number 19
Frontispiece: Catalogue Number 46

California Impressionists

Design: Ron Evans, Barry Stock (Kudzu Graphics)
Body Copy: Monotype Spectrum
Printed in an edition of 30,000

*A presentation of the Atlanta Committee for the Olympic Games (ACOG) Cultural Olympiad, organized by
the Georgia Museum of Art and The Irvine Museum. Partial support for the exhibitions and programs at the
Georgia Museum of Art is provided by the Georgia Council for the Arts through appropriations of the Georgia
General Assembly and the National Endowment for the Arts. A portion of the museum's general operating funds
for this fiscal year has been provided through a grant from the Institute of Museum Services, a federal agency that
offers general operating support to the nation's museums.*

Printed in Singapore

Library of Congress Cataloging in Publication Data
California Impressionists: a presentation of The Atlanta Committee for the Olympic Games
(ACOG) / organized by the Georgia Museum of Art and The Irvine Museum.
An exhibition catalogue with essays by Susan Landauer, Donald D. Keyes, and Jean Stern.
(pbk.) ISBN 0-915977-25-7 (hc.) ISBN 0-915977-22-2
1. Impressionism (Art) – California, Southern – Exhibitions. 2. Painting, American –
California, Southern – Exhibitions. 3. Painting, Modern – 20th Century –
California, Southern – Exhibitions.
I. Landauer, Susan, 1961-. II. Keyes, Donald D., 1940 -. III. Stern, Jean, 1946- . IV. Atlanta
Committee for the Olympic Games. V. Georgia Musem of Art. VI. Irvine Museum.
ND230.C32S626 1996
759.194'9'07475818 — dc20
95-52396

TABLE OF CONTENTS

INTRODUCTION

WE TAKE GREAT PRIDE AND PLEASURE IN JOINING WITH THE GEORGIA Museum of Art to present this magnificent exhibition of California Impressionist paintings.

The mission of The Irvine Museum is to preserve and display California art of the Impressionist period, and it is our goal to present these works of art not only to our constituents in California but also to people throughout the United States and the world over. The paintings that comprise California Impressionism reflect the highest standards of American art. Furthermore, those that focus on landscapes encapsulate the unique qualities of California Impressionism by combining beauty with historical significance and, most of all, a deep reverence for nature. These paintings testify in a most eloquent manner to the need for enlightened environmental management. The ageless beauty of our land was present a century ago for these Impressionists and some of it still exists for us today. We must strive to preserve what remains of this beauty, not only for ourselves, but for generations to come.

Over the past two years, we have enjoyed the opportunity to work with representatives of the Georgia Museum of Art and the Cultural Olympiad in the development of this exhibition. Although this project is the successful culmination of substantial effort by many, I would particularly like to thank Annette Carlozzi, producer of visual arts programs for the Cultural Olympiad, and William Eiland and Donald Keyes of the Georgia Museum of Art, for their inspiration and leadership, and the authors, including our own Jean Stern, for sharing their knowledge, scholarship, and skill.

We hope that you enjoy the exhibition and that you will be moved to join us in our concern for preserving the beauty of our environment.

JOAN IRVINE SMITH
President, The Irvine Museum

ACKNOWLEDGEMENTS

I T IS WITH GREAT PRIDE THAT WE AT THE GEORGIA MUSEUM OF ART JOIN WITH THE Irvine Museum and the Atlanta Committee for The Olympic Games/Cultural Olympiad to present this exhibition and catalogue. Both have taught us, as we hope they teach their audiences, to appreciate once again the beauty of American Impressionist paintings, especially those produced in California. We are grateful to the museum's curator Donald Keyes, to the director of The Irvine Museum Jean Stern and his board of directors, and to Annette Carlozzi for their help in organizing this exhibition. The entire staff of the Georgia Museum of Art deserves special thanks for its hard work. Finally, we acknowledge the generous participation of the lenders, in particular Joan Irvine Smith, whose vision as a collector this exhibition and catalogue celebrate.

WILLIAM U. EILAND
Director, Georgia Museum of Art

This exhibition and catalogue are not meant to be a survey of Impressionism in California and as a result they are not comprehensive. Rather the selection suggests the rich diversity of impressionistic painting in California. As Susan Landauer's essay makes clear, Impressionism came late to California, driven in part by the movement's success in the East and Midwest and sustained by the state's booming economy and relatively conservative taste. None of this detracts from the sheer beauty of the works, as demonstrated by this exhibition and catalogue.

The literature on California Impressionism tends to present the art of Northern and Southern California as separate experiences, and largely they were; however, in this exhibition they appear under one rubric, with Impressionist paintings from San Francisco and Monterey mixed indiscriminately with those from Los Angeles/Pasadena, Laguna Beach, and San Diego. Moreover, Impressionism is here considered in its broadest terms, with Tonalist as well as early Modernist paintings hung together.

The entire project began with the collections of Joan Irvine Smith, Joan Irvine Smith Fine Arts, and The Irvine Museum. The exhibition rapidly moved beyond those collections. At every step of the way I had the encouragement and support of everyone involved with The Irvine Museum. In particular, Joan Irvine Smith and Jim Swinden have been graciously generous, supportive, and enthusiastic collaborators throughout the project. My close association with Jean Stern, executive director of The Irvine Museum, has been the model of collaboration. Quick with informative insights as well as managerial details, he is in large part responsible for this project's success.

From the very beginning Susan Landauer reached beyond her role as essayist. Knowledgeable about the arts in California, she has provided invaluable information and criticism, without which I cannot imagine this catalogue being the publication it is. Pat Trenton, Harvey Jones, Whitney Ganz, and John Dilks made useful suggestions along the way. Richard Gadd and George Stern assisted with the procurement of images. Mr. and Mrs. Morton Fleischer were generous with images of their fine collection, as was Professor Richard Brauer with his museum's painting. Many private collectors opened their homes to me. I am especially appreciative of those who allowed me to take their prized possessions from them for such a long time. No publication of this magnitude appears without the contributions of many people. Jennifer DePrima gathered images, collated lists, and edited text, all the while admirably retaining her composure. The editorial skills of Laura Mullins also contributed greatly to this publication. Bonnie Ramsey guided the entire package through its many phases, and Ron Evans and Barry Stock of Kudzu Graphics turned the raw materials into this beautiful publication. Adam Young has served as my loyal and talented assistant, and Valerie Aldridge has worked alongside me making my gaffes seem a little less so. Working with the Cultural Olympiad can be a daunting task, but Annette DiMeo Carlozzi and Ruth Resnicow have made this much easier.

DONALD D. KEYES
Curator, Georgia Museum of Art

I WOULD LIKE TO THANK NUMEROUS INDIVIDUALS WHO GENEROUSLY SHARED THEIR TIME and expertise. My research was greatly aided by the staffs of several museums, galleries, and archives: Jean Stern and Merika Adams Gopaul of The Irvine Museum; Tania Rizzo of the Pasadena Historical Museum; Jane Glover of the M. H. de Young Memorial Museum; Alfred C. Harrison and Jessie Dunn-Gilbert of the North Point Gallery; David and Jeanne Carlson of 20th Century Paintings & Sculpture; Barbara J. Klein of the Craftsman's Guild and California Heritage Gallery; Whitney Ganz of William A. Karges Fine Arts; George and Irene Stern of George Stern Fine Arts; and Ray Redfern of Redfern Gallery. Special thanks go to Patricia Trenton for carefully reading my manuscript, making helpful comments, and providing numerous fruitful leads. Trenton's exhibition catalogue, *California Light,* was indispensable for my research. I would also like to thank Nancy Moure, since without her extensive publications on California Impressionism, this book would have been considerably more difficult. Other individuals who helped along the way include Dr. Edward Boseker, Marcel Vinh, Joseph Moure, Charlotte Braun White, Mara Goldman, and Donna H. Fleischer. Finally, I would like to thank Donald Keyes, the driving force of *California Impressionists,* for his guidance and good humor throughout.

SUSAN LANDAUER

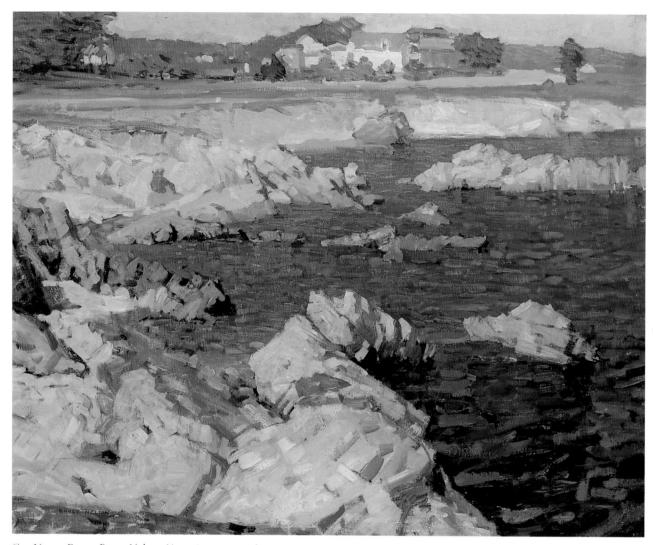

Cat. No. 34 Ernest Bruce Nelson (American, 1888-1952)
 Pacific Grove Shoreline, c. 1915
 Oil on canvas
 24 x 30 inches
 Collection of Patricia and John Dilks

IMPRESSIONISM'S INDIAN SUMMER:
The Culture and Consumption of California "Plein-Air" Painting
Susan Landauer

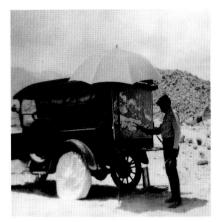

Figure 1 Alson Clark painting at Lone Pine in the Owens Valley in the High Sierra, c. 1921. Photograph, Alson Clark Photo Album. Collection of Carol and Alson Clark.

FROM THE EARLY 1910S TO THE END OF THE 1920S, SOUTHERN CALIFORNIA WAS THE SITE of a curious pocket of prolonged and stubborn conventionality. A "beautiful anachronism," was Michael McManus's apt characterization of the extraordinary efflorescence of Impressionism in those years.[1] Arriving several decades after Monet painted *Impression: Sunrise* (1872), the canvas that gave the movement its name, California's *plein-air* movement can justly be called Impressionism's Indian summer — one long, last breath of life before expiring on the shores of the Pacific coast.[2] This chapter of Impressionism was remarkable not only for its belatedness but also for its fervor. From the dusty banks of Pasadena's Arroyo Seco to the beaches of San Diego Bay, artists deserted their studios to take up painting out of doors (Figs. 1 and 2). It was unimportant that their movement had long since faded in France and been superceded by Fauvism, Cubism, Futurism, and a host of other modern "isms." Southern California had found its artistic *métier;* as the *Los Angeles Times* critic Antony Anderson put it, Impressionism was not one of many modes from which an artist could choose — rather, it was the only way to paint.[3]

The same could hardly be said of Northern California, where a moody tonalism held sway well into the 1920s. San Franciscans became acquainted with French Impressionism as early as 1891, when works by Monet and Pissaro were exhibited at the San Francisco Art Association galleries.[4] Their city also hosted the movement's first major survey exhibition in the state — at the 1915 Panama-Pacific International Exposition, often considered the event that popularized Impressionism in Califor-

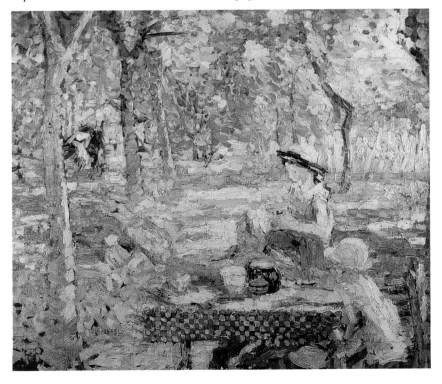

Cat. No. 39 Joseph Raphael (American, 1869-1950)
Tea in the Orchard, c. 1916
Oil on canvas
39 x 46¾ inches.
Collection of John Garzoli

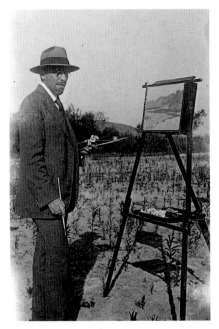

Figure 2 Maurice Braun painting in
the San Diego back country, 1916.
Photograph, Braun Family Album.

nia. Yet, Impressionism never really took hold in the North. San Francisco could lay claim to Joseph Raphael (Cat. No. 39 and Fig. 3), though he spent most of his time painting abroad. The movement gained more than a toe-hold on the Monterey peninsula with E. Charlton Fortune, William Ritschel, and Mary DeNeale Morgan. There was also the Oakland-based Society of Six, whose work combined aspects of Fauvism and Post-Impressionism. But San Francisco remained the locus of a far quieter strain of painting, exemplified by the tranquil, often melancholy, landscapes of artists such as Gottardo Piazzoni and Xavier Martinez (Fig. 4). As the art historian Steven Nash has observed, these modest canvases expressed a mood that was not always one of Edenic hope.[5] They were the temperamental opposite of the sunny optimism sweeping through Southern California, manifested in the trend Antony Anderson defined as Impressionism.

Admittedly, Anderson's conception of the movement was broad: most of the painting he described was not Impressionism in the orthodox sense, but a synthetic style that drew a measure of influence from the Barbizon School. Nonetheless, the Southern Californian variety fit comfortably within the Impressionist family with its concern for color and light, broken brushwork, and the capture of a unique moment in nature. By the late twenties, countless artists were working along these lines, possibly the largest concentration of *plein-air* activity to date. The phenomenon would seem to illustrate the Chinese proverb that the candle always burns brightest before going out. But, of course, the reverse is generally true of art movements. How, then, are we to account for this peculiar occurrence? Why did Impressionism take root and flourish with such energy in Southern California?

Certainly an important reason for the flowering of Impressionism there was the lure of the climate, which was much warmer than that of the North, known for its chilly fog. With its perpetual sunshine and year-round painting conditions, Los Angeles could not help being a magnet for artists seeking to study the effects of light out of doors. Indeed, during the early part of this century, the Southland was widely advertised as a veritable mecca for artists.[6] The famous California light was reputed to approximate that of the south of France. As early as the 1890s, artists of an Impressionist bent were drawn to paint the celebrated coast. By the 1910s, California was an obligatory stop on the grand painting tours of prominent Impressionists from other parts of the country: the New York-based painter Childe Hassam came to paint the California coast in 1914; his colleague William Merritt Chase visited Monterey to teach an outdoor painting class the same year; and Richard Miller, a Midwesterner and member of the Giverny Group, found the charms of Pasadena too alluring for a short visit and wound up staying about twelve months.[7] In 1923 the magazine *California Southland* quoted Miller: "Give me but a little studio on the bank of this lovely canyon, a porch on which to pose my model, a eucalyptus tree nearby and that blue hill for distance and I should never want. No valley in France is more beautiful, no Eastern scene more ready to the painter's hand."[8]

Besides its inviting climate and terrain, Southern California's conservatism has often been cited as a cause for the tenacious hold of Impressionism in the region. The fact that Los Angeles was heavily populated with migrants from Cincinnati, Des Moines, and Chicago is presumed to have given Southern California what the art historian Harvey Jones has called a "prevailing midwestern artistic conservatism" derived from a "nineteenth-century aesthetic."[9] This suggestion, however, does not take into account that Chicago was then the seat of a healthy modernist school. And

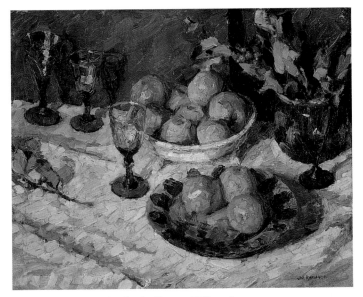

Figure 3 Joseph Raphael, *The Christmas Table*, n.d.
 Oil on canvas
 26 x 33 inches
 Collection of Oscar and Trudy Lemer

Figure 4 Gottardo Piazzoni, *The Fog Bank*, 1930
 Oil on canvas
 34 x 34 inches
 Collection of The Oakland Museum of
 California, gift of the estate of Helen Salz

is it entirely accurate to describe Southern California's cultural climate as conservative? In the 1910s and 1920s the region was, in fact, comprised of a contradictory mix ranging from liberal-progressive Pasadena, with its old-monied gentility, to the Wonder Bread conformism of middle-class Los Angeles, which Willard Huntington-Wright characterized as possessing all the cultural sophistication of a church bazaar.[10] It is important to bear in mind that Southern California was then host to some of the most anti-traditional social experimentation in the country. The region bred scores of mystic cults, nudist colonies, and utopian communities — of which the Purple Mother's Point Loma theosophical society and Krishnamurti's retreat in Ojai are among the best known. Writing in 1921, John Steven McGroarty observed that "Los Angeles is the most celebrated of all incubators of new creeds, codes of ethics, philosophies — no day passes without the birth of something of this nature never heard of before."[11]

A related reason often given for California's extended attachment to Impressionism is the issue of exposure. Such provincialism, so the argument goes, could only be the result of the West Coast's distance from the art centers of Paris and New York. But here, too, the question is complex, given Southern California's large population of transients and visitors, the fact that a good portion of the artists' patronage came from other parts of the country, and that a perusal of the literature of the time reveals that Southern Californians were aware of the latest European avant-garde movements but judged them to be mere fads. Critics such as Mabel Urmy Seares denounced them as superficial, and more important, as not in keeping with the spirit of the West.

Southern California's comparative lack of sophistication may have contributed to Impressionism's Indian summer, but as Bram Dijkstra has so perceptively discerned, art always embodies and expresses a set of moral impulses: "The commodity value of a specific work of art, its currency as an object of desire, therefore, depends largely on continued support from the dominant cultural ideology for the values underlying

the art in question."[12] Southern California Impressionism mirrored the region's self-fashioned image, how the society envisioned itself and desired to be seen from afar. A close examination of this art reveals a complex pattern of choices and omissions that is intimately bound up with the socio-economic development of Southern California in the early part of this century. Briefly summarized, California Impressionism crested with Los Angeles's boom culture and expressed its propensity toward boosterism, nostalgia, and willful escapism.

Impressionism made its debut in Southern California during one of the greatest periods of expansion and prosperity in the country's history. The completion of the Santa Fe Railroad in 1885, which linked Los Angeles to the Missouri Valley at fares of one dollar, sparked a phenomenal real estate boom in the 1880s. Professional boomers and speculators from the Midwest flocked to Southern California, descending upon the region, as one observer noted, "like flies upon a bowl of sugar."[13] But it took the discovery and exploitation of the vast oil deposits coupled with the burgeoning film industry to bring the rush to Los Angeles to a fever pitch. The resulting population influx in the 1920s represented the largest internal migration in American history.[14] The expansion was made possible by a spectacular feat of engineering, the Owens Valley aqueduct, which piped in water from 250 miles away. The irrigation transformed the Southland from a dry, semi-arid desert, sparsely vegetated with cactus and dry brush, into the richest agricultural region in America. As a hotel directory boasted in 1926, "Anything will grow here — from the fleeciest and finest grades of cotton to the rarest of exotic fruits and flowers, vegetables and cereals, all of them thriving wonderfully under the hands of workers that fear neither blizzard nor sunstroke in a climate that leaves them 100% efficient at all seasons of the year."[15] Nearly anything could grow and did. By 1915, $200,000,000 had been invested in citrus alone.[16]

The wealth that flowed into Southern California was as fantastic as its growth. There were signs of prosperity everywhere; each town had its millionaires' row. In Pasadena during the 1920s, much of the social life revolved around events at the Midwick Country Club in Alhambra, which had polo fields that hosted regional and national tournaments.[17] For those who preferred fox hunts, there was the Valley Hunt Club on Orange Grove Boulevard. Lavish resorts, such as the palatial Raymond Hotel and the Hotel del Coronado on San Diego Bay catered to wealthy visitors wintering in Southern California with luxurious diversions such as masquerade balls, Shetland ponies, tennis courts, and croquet grounds.

Southern California's prosperity both fueled and was fed by a veritable orgy of boosterism. Many of the most eloquent spokesmen for the enticements of the Southland were financed by the railroads and tourist industry. The Southern Pacific induced the region's first great professional booster, Charles Nordhoff, to take leave from the New York *Tribune* and come West to write his famous paean to the state, *California for Health, Pleasure, and Residence*. With his emphasis on California's "healthful open-air enjoyments," Nordhoff was among the first to promote what would become one of the state's reigning self-mythologies.[18] Southern California's image as a land of bountiful health spawned a virtual "science" of "climatology" to explain and index the weather's miraculous healing powers.[19] Southern California's sunshine and the growing cult of the outdoors led promoters, such as the physician Joseph Pomeroy Widney, to envision Los Angeles "developing into the health capital of the world, a heliopolis of holistic health culture."[20]

The leisurely life of Southern California was celebrated in the pages of *Land of Sunshine* (Fig. 5) and its successor, the magazine *Out West*, edited by the most zealous of the region's champions, Charles Fletcher Lummis. Lummis had demonstrated his flair for showmanship by arriving in Los Angeles on foot after a highly publicized 3,705-mile hike from Cincinnati. Subsidized by the Los Angeles Chamber of Commerce and bolstered by a substantial Midwestern readership, Lummis's journals spearheaded the search for what historian Kevin Starr has called California's "sustaining ideology."[21] Their pages were filled with articles and photographs extolling the history, regional culture, and special attractions of Southern California, presenting "a dramatization of what it was — or rather, what it day-dreamed it could be" — a land of unparalleled physical beauty, health, and romance.

These were the very themes Lummis's archcompetitor George Wharton James seized upon in his widely read *California Romantic and Beautiful*. British-born James vied with Lummis as California's premier myth-maker, publishing an unending stream of articles and books, which have yet to be fully catalogued, financed in part by the Mount Lowe tourist concession. James's immensely popular publications offered some of the best travel literature about California to date. In *California Romantic and Beautiful*, James painted a breathtaking portrait of the Southland's scenery:

> In thirty-five minutes, see her bejewelled ocean cincture, a galaxy of beach-towns that have the rich blue of the Pacific as an allurement every day in the year, and where surf bathing is indulged in every day, almost without exception... Then, in the other direction stand the mountains, with their Mount Lowe Railway, Carnegie Observatory, and the cool and delicious canyons, where running brooks sing to sunshine-kissed trees, and gigantic mountain

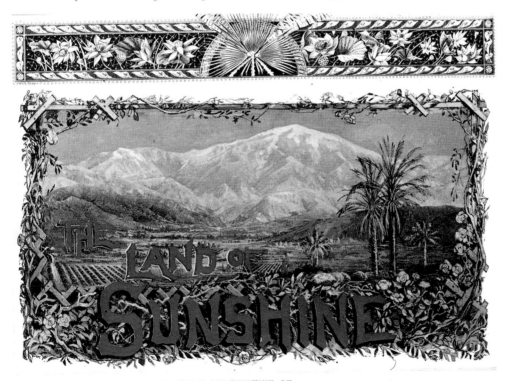

Figure 5 Masthead, *Land of Sunshine* magazine, 1894
Photograph courtesy of the Bancroft Library, University of California, Berkeley.

sides and cliffs keep putting on ever-changing garments of colour and tone for the delecta-
tion of the elect. And between mountains and sea are miles and miles, on either hand, of
orange orchards, lemon groves, avenues of palms, great mesas dotted over with poppies,
lupines and mustard, the groves of stately eucalyptus, and all where the odours of a million
times a million flowers and blossoms unite with the salty tang of the sea air and the pine and
balsam laden breezes from the mountains.[22]

Symptomatic of California's feverish nativism in the 1910s and 1920s were the numerous celebratory publications on California's brief history. Helen Hunt Jackson's Mission-era romance *Ramona* initiated a flurry of articles, books, and plays on the region's Spanish colonial heritage that continued almost unabated through the 1920s. Gertrude Atherton's *California, An Intimate History*, written for the 1915 Panama-Pacific International Exposition, was the first of her many chatty chronicles of the state's history. More artistically ambitious were the lyrical novels and essays of Mary Austin, which eulogized California's indigenous landscape and Hispanic past.

Virtually all of the art critics during Southern California's great boom years encouraged a native subject matter. In 1909 Mabel Urmy Seares, publisher and editor of *California Southland*, set the prevailing tone in an article entitled "The Spirit of California Art." Seares's article amounted to a clarion call advising artists to get out of their dark studios and concentrate on the glories of California's landscape. "Forgetting all petty passions and ambitions," she urged, the artist "must open his eyes and heart to the great beauty of light, landscape and physical perfection to be found on this sunny side of the continent, and then do whatever his hand finds to do."[23]

The authors of *Art in California*, a survey of the state's artistic accomplishments published in 1916, unanimously agreed with Seares that landscape painting offered Californians the greatest promise. The critic Hector Alliot ventured that Los Angeles might become the cradle of a world-class school of art: "There, under the cloudless sky, close to the encircling Sierras, and with nature's boundless beauties on all sides stretching to the shores of the Pacific, we may hope to see evolve within this century the Florence of the new world. It needs only a greater cohesion of ideals to produce there a new plain-air [*sic*] school of international scope and character."[24]

Antony Anderson's regular art columns in the *Los Angeles Times* during the teens and twenties epitomized the bias of Southern California's art press. Anderson, a transplanted Chicagoan, showed the zeal of a born-again Californian by consistently lavishing his attention on local artists. His most glowing praises were reserved for *plein-air* landscape painters, especially those who captured the spirit of the West, which for Anderson, meant: "Not cheap French restaurants, but the lovely vistas of the Arroyo Seco distinguish Los Angeles from other cities; not five-cent theaters, but the marvelous scenic beauties of the Garvanza hills, not little Italian priests in queer little transplanted gardens, but big native California laymen in perennial rose bowers of a hundred acres."[25]

When artists strayed from California to paint, the local press did not hesitate to express disappointment. Fred Hogue, chief editorialist of the *Los Angeles Times*, articulated a sentiment shared by his fellow journalists when he lamented the fruits of Edgar Payne's European visit, exhibited at Stendahl Galleries in 1926: "As I studied the canvases in the present collection," he wrote, "I sensed a feeling of regret that he should have wandered so far. I wished he might have been imprisoned in California, like a bird in a golden cage, that he might have remained as loyal to us as the

Flemish painters of the Low Countries and the British painters of the epoch of Gainsborough and Lawrence to the British Isles."[26] It may have been in part to make up for this infraction that Payne assured Hogue the following year that he considered the Sierra-Nevada range superior to the Alps, a preference Hogue gratefully reported in the local press.[27]

Such expressions of regional pride are not difficult to find among the California *plein-air* artists. Granville Redmond, for example, asserted that Los Angeles's "scenery excels that of France."[28] Benjamin Brown, one of the first Impressionists on the West Coast, conveyed his loyalty to the region in a widely reported gesture: when a New York dealer suggested that Brown conceal his California identity to increase sales of his work, he flatly refused and began painting the word "California" under his signature.[29] Like most Impressionists in California, Brown had come from out of state. Indeed, the vast majority had trained in Chicago, St. Louis, Paris, or New York, establishing their careers elsewhere before moving to the West. They came for reasons of health (Alson Clark, William Griffith) or, in the case of Payne, to take advantage of the economic opportunities in California. Some, like Franz Bischoff and William Wendt, first came as tourists and were sufficiently smitten to return for good.

It would be misleading, however, to portray the California Impressionists as a group of zealous boosters. Clark, who had traveled the world and studied with William Merritt Chase in New York, regretted having to give up the cosmopolitan stimulation of the East, and only reluctantly followed his doctor's advice and boarded a train for California with the hope of curing an ear ailment. As his wife remembered, his impression of Los Angeles upon arriving in 1919 was anything but enthusiastic. Hearing of a "quaint little community" on the seashore, they promptly took an electric car to Venice-by-the-Sea:

> The car turned its back on the mountains and struck out toward the sea. After jolting through rows of sordid little stucco houses, incredibly close together, it pulled up with finality and the conductor announced "End of the Line." "Venice?" Alson asked, unbelieving. The conductor nodded. The place was a realtor's blighted dream in its first stages of disintegration, and there was not need even to alight to learn that Venice was not for us, so we remained on the car, helped the conductor turn the seats, and were back in Los Angeles in time for lunch.[30]

As a group, the California Impressionists were sophisticated cosmopolitans, and not a few were well-heeled world-travelers. Clark, Payne, Brown, Joseph Kleitsch, and others did not allow local pressure to keep them from painting European sights or from making occasional jaunts to Mexico and the Southwest. And they were fully capable of responding pejoratively to excesses of local pride. Guy Rose, the only significant California native of the group, voiced his annoyance with Antony Anderson's flagrant regional bias. In a letter to the *Los Angeles Times* in 1916, Rose complained about the "silly idea that seems to prevail here that every painter in Southern California is the best in the world...it is the artist and not the subject that makes good work."[31]

Yet even Rose succumbed to the local preference for California landscape. Beginning as a Paris-trained painter known for his impressions of fashionable kimono-clad women, he spent the last years of his life painting views of the Carmel coast. Rose's pattern was common among the California Impressionists. Brown, Kleitsch, Bischoff, Maurice Braun, and Hanson Puthuff all began as successful portrait, figure, floral, or still-life painters in other parts of the country before coming to California and settling on landscape as their primary theme. And it was not the blighted land-

Figure 6 Maurice Braun (American, 1877-1941)
Land of Sunshine, n.d.
Oil on canvas
50 x 70 inches
The Fieldstone Collection

scape of Venice-by-the-Sea that they painted; almost without exception, the California Impressionists chose subjects that were intentionally picturesque. Whether consciously or not, therefore, they responded in unison to the regionalist concerns of the moment. Reflecting the rhetoric through which Southern California was packaged and sold, their visions matched those of even the most ardent promoters.

Of the California Impressionists, San Diego-based Maurice Braun came as close as any to envisioning the "California Dream" in paint on canvas. With his taffy-colored palette of pinks, blues, and yellows, Braun's landscapes were consistently sweet. In 1924 his wife, the art critic Hazel Boyer, reported in *California Southland*: "Almost the first statement generally made upon entering a gallery of his work is, 'What happy pictures!' [Mr. Braun] says that he prefers to paint when the sun shines, when the hillsides and foliage sing with color. He may paint a grey day, but it is always luminous, a greyness that shows the presence of the sun somewhere."[32]

Braun's *Land of Sunshine* (Fig. 6), which shares its title with Charles Lummis's booster journal, epitomizes the artist's cheerful optimism, depicting Southern California as a bountiful earthly paradise. By the time this work was painted, the Edenic image of California already had a long artistic tradition, dating back at least half a century to Albert Bierstadt's grand panoramas of Yosemite Valley. Yet, compared with those

spectacular vistas, Braun's Eden is modest and accessible. He does not show us a fantastic, unattainable paradise, but a sunny idyll scaled down for human delectation. With its rich green vegetation and clear-running brook, *Land of Sunshine* conjures a fertile land of plenty. Indeed, this painting might well have illustrated some of the lines from C. R. Pattee's poem by the same name, which appeared in the first issue of Lummis's journal:

> *Come ye! to this fair land of fruits and flowers;*
> *Where balmy ocean breezes ever play;*
> *And all the year the birds sing in the bowers;*
> *Where autumn winds ne'er sadden with their moan;*
> *And sudden chilling changes are unknown;*
>
> *No winter's icy scepter reaches here;*
> *It lies beyond the frozen realm of snow; —*
> *A country yielding happiness and cheer;*
> *Where pleasure, toil, and rest, alike bestow —*
> *On mind and body — vigor, strength, and health;*
> *And rich in boundless resources of wealth.*[33]

Of course, California's promise of boundless wealth, health, and sunshine — "Calitopia," as one turn-of-the-century enthusiast called it — was the paradigm of the region's promoters and advertisers (Fig. 7).[34] Yet, while for developers it served to lure land-buyers West, for Braun the image expressed his intense spirituality. A dedicated theosophist, Braun believed deeply in the all-pervasive divinity of nature. And light, as a manifestation of divine immanence, played an important part in Braun's pantheism. For the theosophists, light is "the life principle, the *anima mundi* pervading the universe, the electric vivifier of all things."[35] Braun's Impressionism, then, was only superficially allied with the French original; its philosophical underpinnings

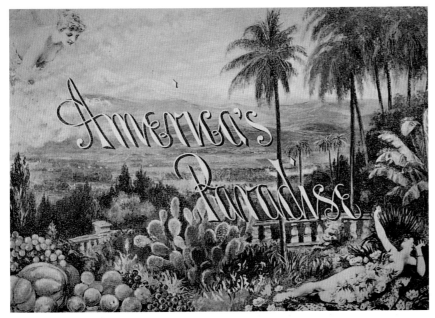

Figure 7 "America's Paradise." Illustration from Norman Baker, *Pasadena and Environments*, promotional brochure published by the Board of Trade, 1893, courtesy of the Archives of the Pasadena Historical Museum.

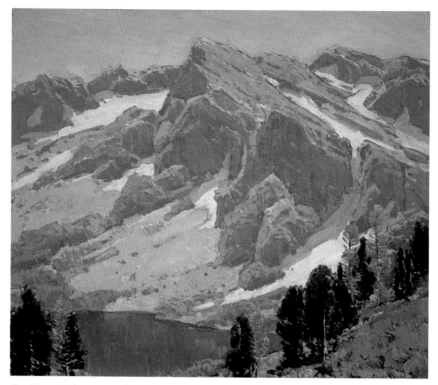

Cat. No. 35 Edgar Payne (American, 1882-1947)
Sierra Divide, 1921
Oil on canvas
24 x 28 inches
Joan Irvine Smith Fine Arts, Inc.

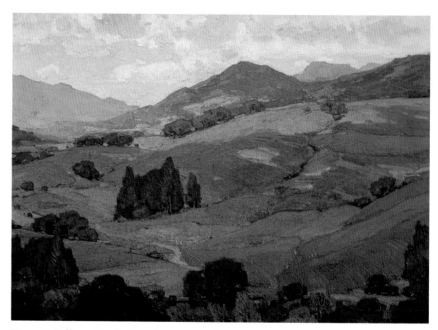

Figure 8 William Wendt (American, 1865-1946)
I Lifted Mine Eyes Unto the Hills, n.d.
Oil on canvas
36 x 50 inches
The Fleischer Museum

had more perhaps in common with the mystical landscapes of the Chinese artist Fan Kuan than with the empirical light studies of Claude Monet.

Braun may have been unusual among the California Impressionists in his allegiance to theosophy, but he was not alone in viewing nature as a source of spiritual renewal. None of the leading landscapists characterized their endeavor as strictly reportorial. Edgar Payne was praised for his exact rendering of geological strata and "correct reproduction of atmosphere,"[36] yet in his primer, *Composition of Outdoor Painting* (1941), Payne took care to emphasize the spiritual nature of landscape painting, telling his readers that "preceding and transcending all visual appearances...are the great invisible qualities to be felt when viewing hills and mountains — their nobility, height, and grandeur — those fine abstract qualities that exhilarate and lift the mind even from visual appearances."[37] Far from cool transcriptions of California's scenery or hedonistic celebrations of the state's bounty, Payne's majestic paintings of the High Sierra (Cat. No. 35) were freighted with moral significance.

Surely, the master of the *paysage moralisé* among the California Impressionists was William Wendt. For Wendt, a pious Lutheran, the notion of California as a New Eden was hardly an idealized fiction, the product of promoters' over-active imaginations. Wendt himself described the landscape of Southern California as a pristine Eden:

> *The perfection of this spring day and the gladness thereof make one think of Genesis when the earth was young and the morning stars sang to each other...The peace, the harmony which pervade all, give a Sabbath-like air to the day, to the environment. One feels that he is on holy ground, in Nature's Temple...The perfume of the flowers and of the bay tree are wafted on high, like incense...The birds sing sweet songs of praise to their Creator. In the tops of the trees the soughing of the wind is like the hushed prayers of the multitude in some vast cathedral...Here, away from conflicting creeds and sects, away from the soul-destroying hurly-burly of life, it feels that the world is beautiful; that man is his brother; that God is good.[38]*

In works such as *When All the World is Young* (1911), *The Land of Heart's Desire* (1910), and *I Lifted Mine Eyes Unto the Hills* (Fig. 8), paintings which the art historian John Alan Walker called "painted hymns," Wendt enacts this scene of undefiled nature.[39] Here California appears in eternal springtime beneath a mantle of fresh green grass. In the hills and canyons around Santa Ana and Laguna Beach during the region's brief wet season, Wendt found his enduring metaphor and California's central myth as a place of new beginnings, where the individual was free to make himself anew.[40]

It was perhaps in their quest for a spiritually enriching vision that the landscapes of the California Impressionists often neglected the human presence. People rarely, if ever, appear in Wendt's paintings or in those of Braun. Unlike the French Impressionists or even their American progeny in the East, the California *plein-air* painters sought out isolated nature, sometimes making lengthy and arduous treks into the wilderness. Their toughness and pluck in making these journeys was often reported with great admiration in the press. Critics such as Anderson and Hogue rarely missed a chance to portray the *plein-air* artists as archetypal Californians, reveling in the "glory of their sports" as they carried their palettes and paints to ever more remote sites.[41] Even the frail and often sickly Edgar Payne was characterized as a robust outdoorsman, tireless in his Sierra climbs.[42]

Considering that Southern California had become a world-renowned tourist mecca by the 1910s, it may seem surprising that the California Impressionists general-

ly neglected to paint the year-round din of the holiday-makers at the thriving resorts. Although Los Angeles's "galaxy of beachtowns" — Hermosa Beach, Redondo Beach, Playa Del Ray, Santa Monica, and Venice — were all within minutes of downtown by electric train, they rarely appear in the work of California Impressionists. This was indeed a major departure from orthodox Impressionism and is perhaps the feature that most distinguishes the California phase of the movement. Beach picnics and boating parties had always been a staple of Impressionism, whether one thinks of Auguste Renoir or William Merritt Chase. The French and East-coast Impressionist landscapes are almost invariably social landscapes. As one art historian observed: "Whether there are figures lolling in gardens, or walking down paths, houses set confidently in the fields or at the edge of cliffs, the human presence is always felt."[43]

There were, of course, exceptions to the rule. The iconoclastic Kleitsch painted the tourists at Laguna Beach, and visitors such as Louis Betts did not neglect to depict the activities of the vacationers. Betts, an Impressionist from Chicago, seems to have found the mid-winter sunbathing at Coronado Beach too queerly Californian to pass up (Cat. No. 1). Wendt's depiction of Avalon Bay is more typical of the California approach (Fig. 9). In this painting, Wendt has omitted any trace of Catalina's bustling boardwalk. A sunny day would ordinarily draw human droves to this popular waterfront, but Wendt's view is starkly uninhabited.

In fact, the artists who clustered in the tourist towns of California — notably Laguna Beach and Carmel — were the very painters who concentrated on wild and untrammeled views of the coastline. In Laguna Beach — the "Riviera of America," as the local chamber of commerce liked to call it — the ocean itself was the subject of choice.[44] Frank Cuprien spent more than 50 years painting the breakers below his studio home on the low-lying sandstone bluffs. Paintings such as *A Summer Evening* (Cat. No. 15) show his concern with the capricious light effects caused when sky meets water, especially the soft opalescence of a hazy sunset or the shimmering iridescence of a moonlit evening.

In Northern California the stronghold of Impressionism was the scenic coastline around Carmel. With its dramatic sheer cliffs, jagged coves, and salt-bleached cypresses, the area drew scores of *plein-air* artists throughout the early decades of the century. Perhaps no artist is more closely identified with Carmel than Mary DeNeale Morgan. Morgan's canvases in oleo tempera, a blend of pigments especially suited for brilliant effects, portray the undulating sand dunes of the coast in broad sweeping strokes. But the theme to which she returned again and again was the wind-sculpted cypress (Cat. No. 33). Morgan never tired of painting this distinctive Northern California tree in all conditions of weather, whether through the golden haze of a late afternoon or thrashing in a violent storm.[45]

Unquestionably, Carmel's premier marine painter was William Ritschel. German-born Ritschel settled in the Carmel Highlands in 1918 and spent the next 30 years painting the ocean in all phases, especially its savage moods. His obsession with the primal power of the sea might ally him with the 19th-century American realist Winslow Homer, but his exploitation of the crashing surf for virtuoso displays of brushwork places him well within the Impressionist camp (Cat. No. 45).

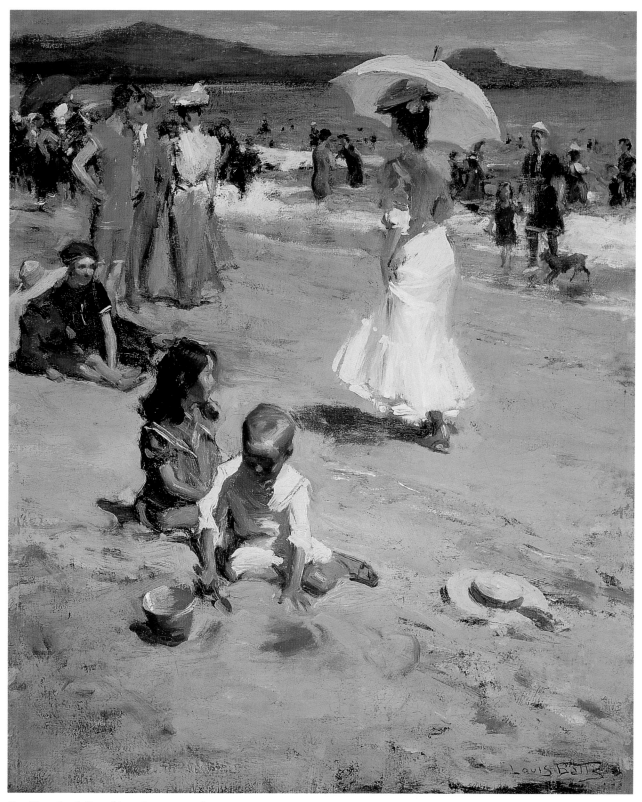

Cat. No. 1 Louis Betts (American, 1873-1961)
Mid-Winter, Coronado Beach, c. 1907
Oil on canvas
29 x 24 inches
The Irvine Museum

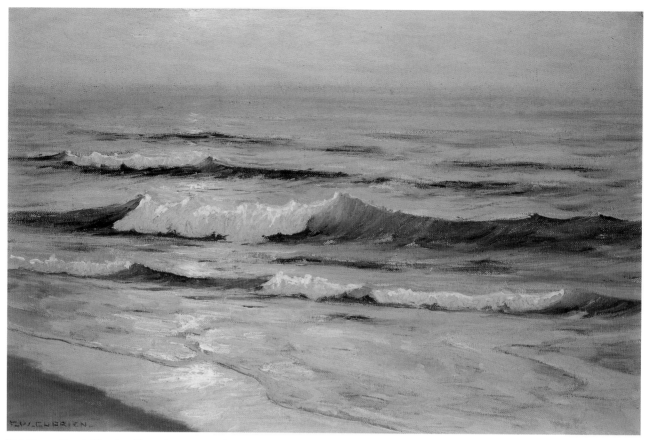

Cat. No. 15 Frank Cuprien (American, 1871-1948)
 A Summer Evening, n.d.
 Oil on canvas
 11 x 17 inches
 Joan Irvine Smith Fine Arts, Inc.

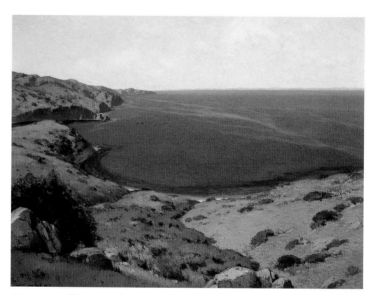

Figure 9 William Wendt (American, 1865-1946)
 Avalon Bay, n.d.
 Oil on canvas
 30 x 40 inches
 Collection of Marcel Vinh and Daniel Hansman

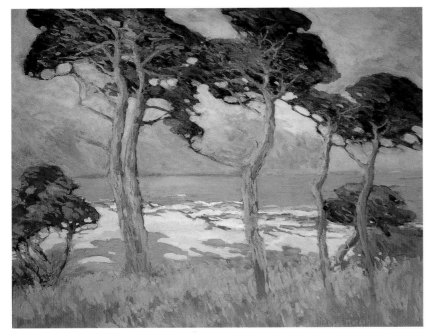

Cat. No. 33 Mary DeNeale Morgan (American, 1868-1948)
Cypress at Monterey, n.d.
Watercolor and gouache on paper
18½ x 24½ inches
Joan Irvine Smith Fine Arts, Inc.

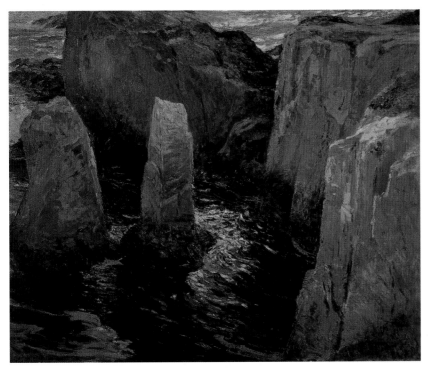

Cat. No. 45 William Ritschel (American, 1864-1949)
Mammoth Cove, n. d.
Oil on canvas
50¼ x 60½ inches
Monterey Peninsula Museum of Art,
gift of the Ritschel Memorial Trust

Closer still to orthodox Impressionism were the seascapes by Guy Rose, who spent summers in Carmel during the late 1910s. Like Monet, Rose sometimes painted a series of the same subject in different conditions of weather. His views of Point Lobos might be rendered on a clear day (Cat. No. 48), or they might be wrapped in a blanket of Northern California fog.

Although its beaches and shoreline are important 20th-century symbols of California, the Pacific was only one of many themes that distinguish the work of West Coast *plein-air* artists from that of Impressionists elsewhere in the country. In their efforts to glorify the local physiognomy, these artists frequently gravitated to the features most particular to the California landscape. Many of them painted the majestic live oak, whose round-topped silhouette was a common sight dotting the rolling hills of the inland countryside (Cat. No. 50). One of their most enduring subjects —

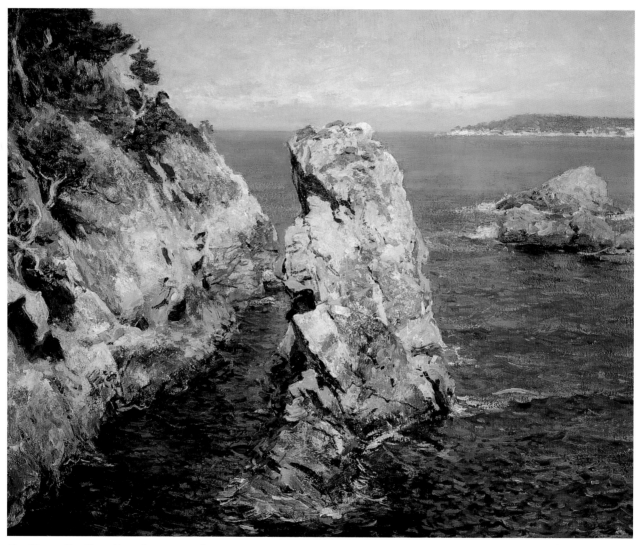

Cat. No. 48 Guy Rose (American, 1867-1925)
Point Lobos, n.d.
Oil on canvas
24 x 29 inches
Joan Irvine Smith Fine Arts, Inc.

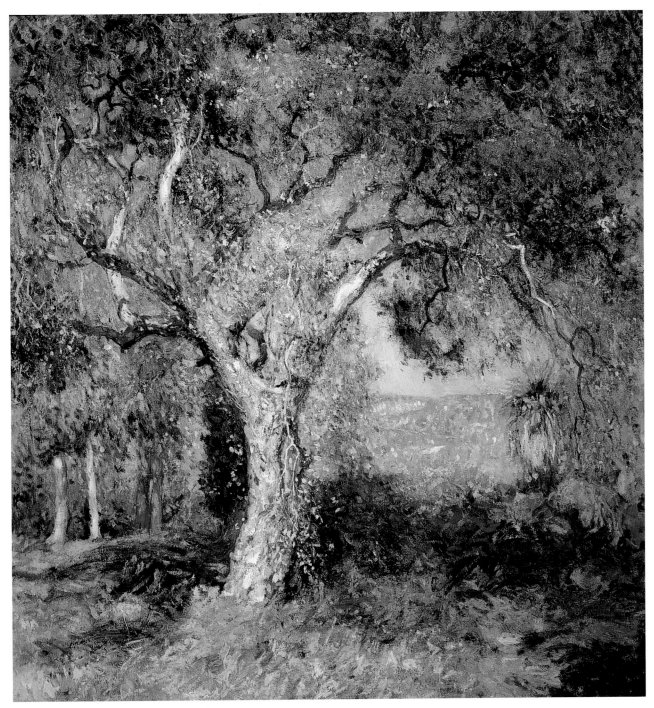

Cat. No. 50 Guy Rose (American, 1867-1925)
 The Oak, c. 1916
 Oil on canvas
 30 x 28 inches
 The Gianetto Collection

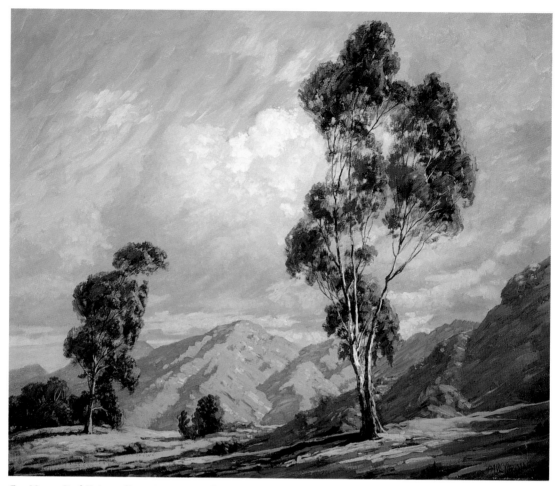

Cat. No. 22 Paul Grimm (American, 1892-1974)
Eucalyptus and Clouds, n.d.
Oil on canvas
25 x 30 inches
Joan Irvine Smith Fine Arts, Inc.

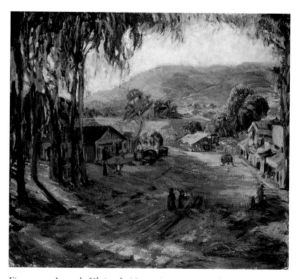

Figure 10 Joseph Kleitsch (American, 1886-1931)
Old Laguna, 1924
Oil on canvas
36 x 40 inches
Collection of Dr. and Mrs. Edward H. Boseker

indeed a leitmotif of the group — was the graceful eucalyptus tree (Cat. No. 22 and Fig. 10). An Australian import, these fast-growing trees were planted by the thousands in the middle of the 19th century as a coastal windbreak. By 1894 more than ten million were counted in Southern California alone. The Impressionists made the eucalyptus a centerpiece of their repertory, taking full advantage of the possibilities for bravura brushwork in rendering its distinctive attenuated leaves. Kleitsch, Rose, Clark, Braun, Payne, and Elmer and Marion Kavanagh Wachtel all painted the eucalyptus. The notable exception was Wendt, whose blocky stroke was more compatible with the sycamore and oak. So many artists painted the eucalyptus that by the late 1920s, the critic Merle Armitage felt compelled to call them the "Eucalyptus School."[46]

California's reputation as a garden state where a large variety of exotic plants could grow assured that the *plein-air* artists would paint the abundant variety of colorful flowers that flourished there (Cat. No. 7). In Pasadena Franz Bischoff specialized in oil paintings and ceramics featuring roses (Cat. No. 2), and did a brisk business selling to the tourists. By 1908 when Bischoff completed his studio house on the Arroyo Seco, the rose had become virtually synonymous with Pasadena. The tradition began in the late 19th century with the lavish botanical gardens of Carmelita, a huge estate that eventually became a public park. Pasadenans were soon outdoing themselves to produce displays of botanical pyrotechnics, turning the city into a year-round riot of color. In 1890 the annual Tournament of Roses institutionalized Pasadena's floral bent with an extravagant rose parade in downtown Pasadena, an event which ultimately became one of the mainstays of college football, the annual Rose Bowl game.

The flower most closely associated with California — and the one the *plein-air* artists overwhelmingly preferred — was the California golden poppy. The state flower, which once bloomed in profusion after spring rains, attracted virtually all of the Impressionists. Some painters — notably the Santa Barbara-based John Gamble — virtually made their careers painting poppies. Gamble's "prairie fires," as critics affectionately dubbed his canvases, often combined poppies with lupine to produce a dazzling contrast of orange and purple (Cat. No. 20).[47] This use of complementary colors, using Chevreul's optical theory to brilliant effect, proved irresistible, as well as financially lucrative for many California Impressionists. Granville Redmond's poppies and lupine were so popular that he could scarcely keep up with the demand (Cat. No. 40).[48]

In Pasadena, where an enormous field of poppies extended right into the city, artists did not need to mingle the golden flower with lupine to achieve such a dramatic contrast of color: the San Gabriel mountains, which loomed behind Pasadena like a fantastic stage set, provided the mauves and purples they were looking for. Of course, the Pasadena artists were not the only Impressionists in California to interpret California in purples and golds — as far north as Tiburon, Seldon Gile used the combination with striking success (Cat. No. 21). But the artists of the Arroyo Seco — Bischoff and Brown, along with the husband and wife team Elmer Wachtel and Marion Kavanagh Wachtel — may have developed the idea furthest. Bischoff and Brown keyed their colors to a fever pitch of vibration (Cat. No. 8), while the Wachtels softened them to produce Maxfield Parish-like reveries in otherworldly tints of apricot and lavender (Cat. No. 56).

These paintings went well beyond nature into the realm of fantasy; indeed, they were not far removed from the orange crate labels that idealized the California landscape as a sun-splashed, purple-mountained Arcadia during the teens and twenties.

Cat. No. 7 Benjamin C. Brown (American, 1865-1942)
 The Joyous Garden, n.d.
 Oil on canvas
 30½ x 40½ inches
 Joan Irvine Smith Fine Arts, Inc.

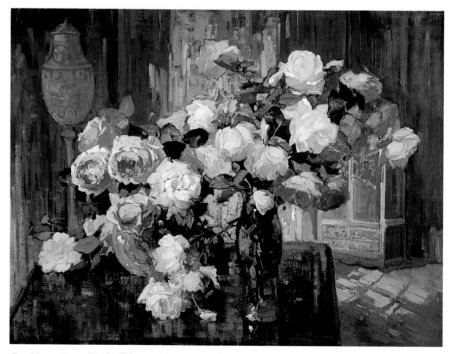

Cat. No. 2 Franz Bischoff (American, 1864-1929)
 Roses, n.d.
 Oil on canvas
 30 x 40 inches
 Joan Irvine Smith Collection

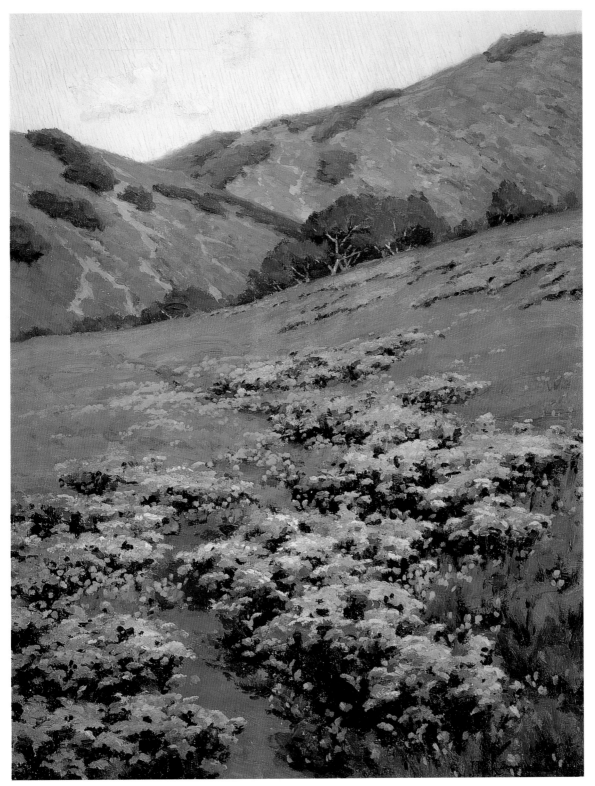

Cat. No. 20 John Gamble (American, 1863-1957)
Joyous Spring, n.d.
Oil on canvas
26 x 20 inches
Joan Irvine Smith Fine Arts, Inc.

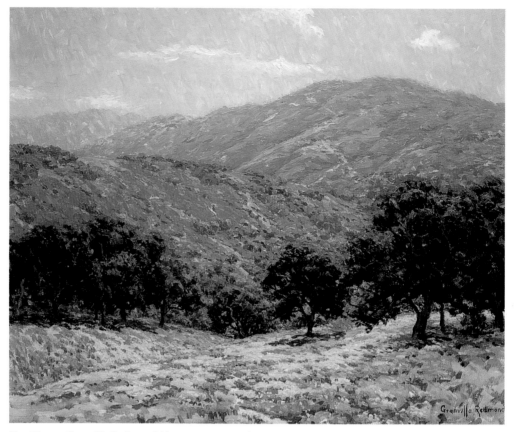

Cat. No. 40 Granville Redmond (American, 1871-1935)
Flowers Under the Oaks, n.d.
Oil on canvas
20 x 25 inches
Joan Irvine Smith Collection

Cat. No. 21 Seldon Connor Gile (American, 1877-1947)
Boat and Yellow Hills, n.d.
Oil on canvas
30½ x 36 inches
Collection of The Oakland Museum of California,
gift of Dr. and Mr. Frederick Novy, Jr.

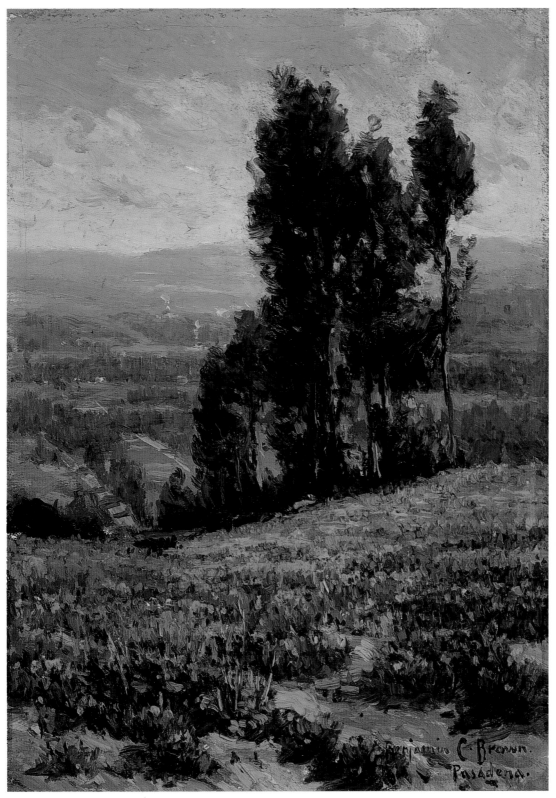

Cat. No. 8 Benjamin C. Brown (American, 1865-1942)
 Pasadena, n.d.
 Oil on canvas
 14 x 10 inches
 Private Collection

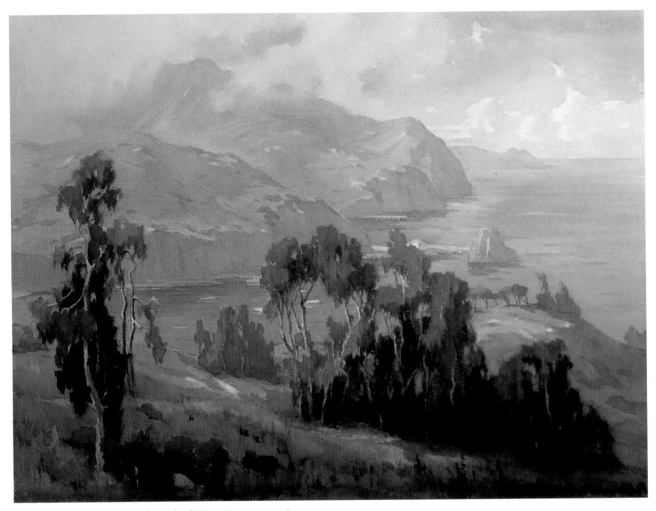

Cat. No. 56 Marion Kavanagh Wachtel (American, 1876-1954)
Enchanted Isle, n.d.
Watercolor on paper
23½ x 31¾ inches (sight)
The Fieldstone Collection

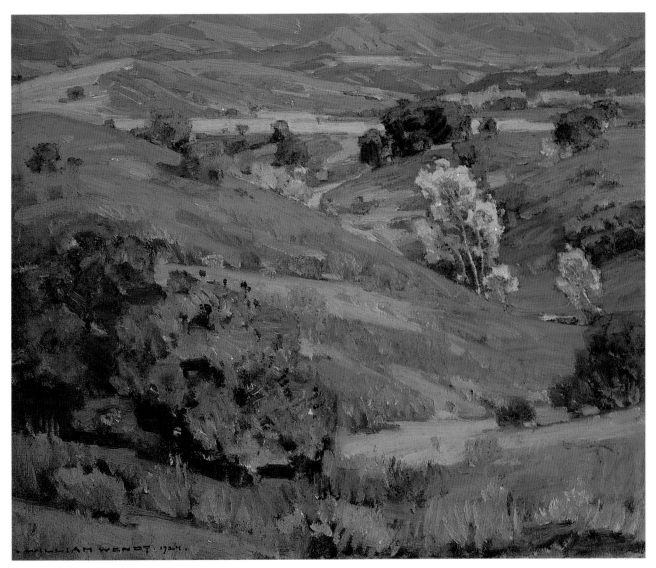

Figure 11 William Wendt (American, 1865-1946)
California Gold, 1924
Oil on canvas
20 x 24 inches
The Redfern Gallery, Laguna Beach, California

Max Schmidt, the San Francisco-based label designer who established the prototype, may very well have taken his cue from the Pasadena artists. Glimpsed in grocery stores across the country, the colors purple and orange, with their variations blue and gold, came to signify California. If they were not the originators, the *plein-air* artists certainly helped to reinforce the state's emblematic colors — colors that found manifestation not only in Sunkist crate labels but also in the University of California's insignia, and even in such unlikely instances as the 1960s vogue for the California-manufactured varieties of LSD known as "orange sunshine" and "purple haze."

California's association with gold has, of course, had a long history. Even before the Gold Rush, the Spanish legend of El Dorado portrayed the region as a land rich in gold and other treasure. California's natural terrain, with its grass-covered hills burned to a tawny gold for much of the year, emphasized these associations, as did the fields of wild mustard and poppy, so abundant before the American conquest that passing Spanish sailors described California as "La Tierra del Fuego" (the Land of Fire).[49]

The Southern California artists were well aware of those connotations and made the most of them. Countless paintings bear titles alluding to "golden state" imagery. Typically, as in Wendt's *California Gold* (1924), these artists intensified the hue of hillside foliage until it virtually glowed (Fig. 11). Bischoff took a less obvious tact in *When Golden Sunbeams Shimmer*, which depicts the radiant light of quivering eucalyptus leaves at sunset. Redmond struck an ingenious formula in *Silver and Gold* (Cat. No. 41), juxtaposing the silvery reflections of the Pacific against a carpet of California poppies. He may have been inspired by Hassam's *The Silver Veil and the Golden Gate, Sausalito, California* (Cat. No. 28), a view that takes its name from San Francisco's "silver veil" of fog that so captivated the artist with its soft, poetic light.[50]

If California Impressionist paintings are filled with allusions to the state's mythic associations with precious ore, they are positively rife with its fabled Spanish past. In this, they partake of Southern California's flourishing mission revival, which began in the mid-1880s and reached an apex in the 1920s. Helen Hunt Jackson's immensely popular novel of star-crossed Indian lovers, *Ramona*, seems to have triggered the craze. As Carey McWilliams has observed, the book was perfectly timed to coincide with Southern California's first tourist and real estate boom, and gave the region an aura of romance that would prove indispensable for developers in the coming decades. During the 1910s and 1920s, picture postcards by the tens of thousands showed "the school attended by Ramona," and "the place where Ramona was married," while Ramona curios and souvenirs were sold in tourist shops throughout Southern California.[51]

The mission era's grip on the popular imagination was perhaps best expressed in the tremendous success of John Steven McGroarty's outdoor extravaganza, *The Mission Play*, which drew an estimated 2.5 million people between 1912 and 1929. For his cultural contribution, McGroarty was named poet laureate and knighted by the Pope and by the king of Spain.[52] Although the era of Franciscan rule had lasted no more than the span of a human lifetime (1769-1834), it was embraced as representing the distinctive life and culture of California, so much so that mission architecture became the state's semi-official style, especially in the Southland, where untold numbers of train stations, hotels, banks, and city halls bear the imprint of Franciscan ecclesiastical design.

The restoration of California's missions, spearheaded by Charles Lummis, attracted large numbers of artists as well as tourists to their grounds in the first decades of the century. By far the most widely visited was San Juan Capistrano, south of Laguna Beach.[53] Founded in 1776, the "Jewel of the Missions" was among the first subjects that

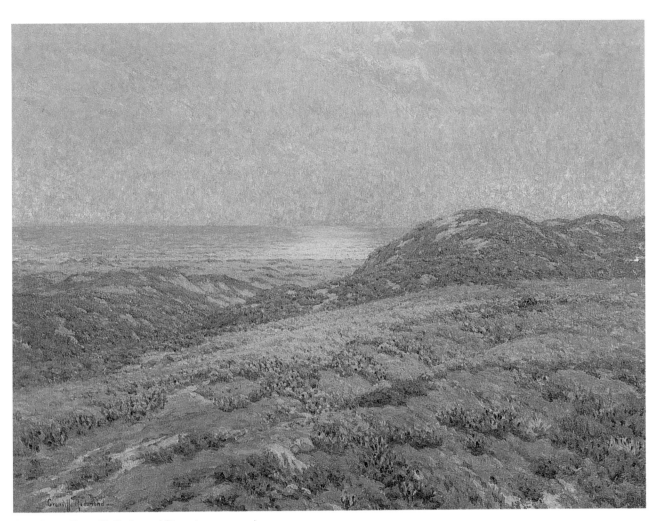

Cat. No. 41 Granville Redmond (American, 1871-1935)
 Silver and Gold, c. 1918
 Oil on canvas
 30 x 40 inches
 Laguna Art Museum,
 gift of Mr. and Mrs. J. G. Redmond

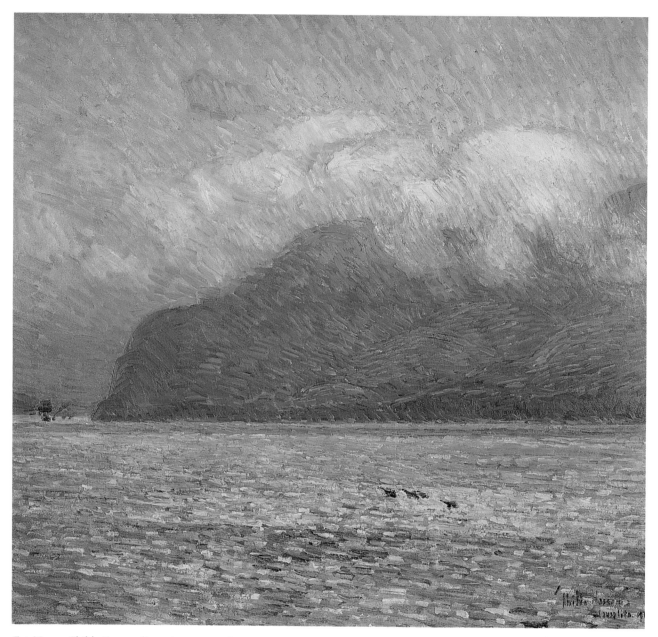

Cat. No. 28 Childe Hassam (American, 1859-1935)
The Silver Veil and the Golden Gate, 1914
Oil on canvas
30 x 32 inches
Valpariso University Art Gallery and Collections, Sloan Collection

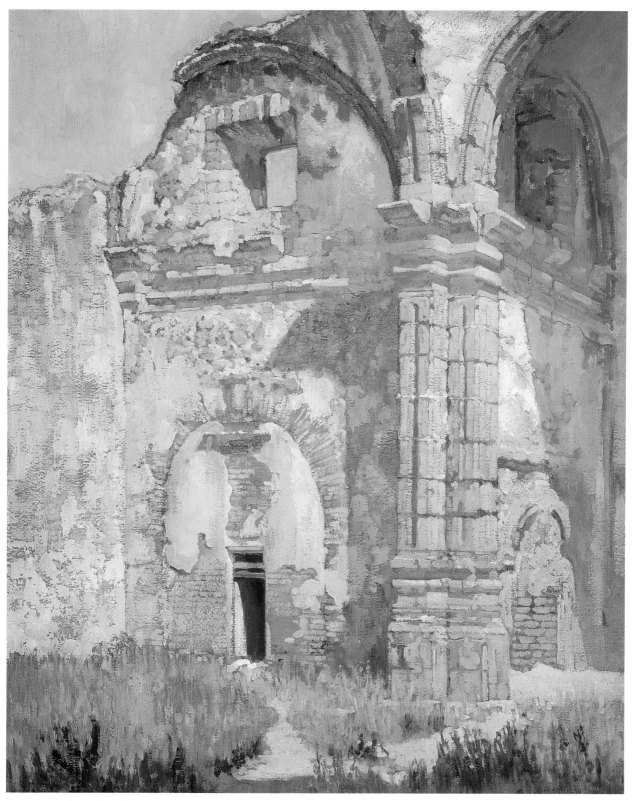

Cat. No. 11 Alson Clark (American, 1876-1949)
 Ruins of San Juan Capistrano, n.d.
 Oil on board
 31 x 25 inches
 Joan Irvine Smith Fine Arts, Inc.

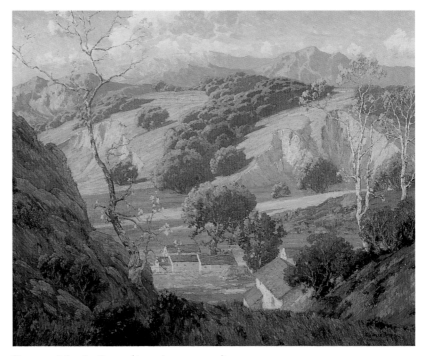

Figure 12 Maurice Braun (American, 1877-1941)
California Valley Farm, c. 1920
Oil on canvas
40 x 50 inches
Collection of Joseph L. Moure

Alson Clark painted when he arrived in Southern California in 1919. Confirming his reputation as an "architectural portraitist," Clark scrupulously rendered the patterning of exposed brickwork in paintings such as *Ruins of San Juan Capistrano* (Cat. No. 11).

Clark was not alone in emphasizing the neglect and deterioration of the missions despite their ongoing restoration. Although California *plein-air* artists often painted the colorful gardens in brilliant sunlight, they just as frequently stressed the decay of the crumbling structures — with all the nostalgia such treatment evoked. Wendt's *Of Bygone Days* and *An Echo of the Past* recall the Barbizon School's fondness for the aging relics of vanished epochs. Even the thoroughgoing Impressionist Clark took a decidedly romantic turn in *Moonlight, San Juan Capistrano*, which bathes the facade of the mission in a pale, ghostly light.

In their taste for subjects with historic resonance, the California *plein-air* artists diverged sharply from the French Impressionists, who had emphatically rejected *la France historique* and its attendant sentimental baggage. The Californians deliberately sought out landscapes with a sense of nostalgia (Fig. 12). This required some determination and imagination since it was not easy to find thatched cottages and antiquated stone bridges in California. But Paul Lauritz managed to give Los Angeles the look of a quaint village in *Old Los Angeles*, while Braun found or perhaps invented an edifice that might easily pass for a rustic Italian villa.

For those seeking picturesque harbors in the Southland, the pickings were especially slim. In 1924 Edgar Payne had to travel as far as Brittany to find sufficiently charming fishing vessels. As Fred Hogue ruefully explained, Payne had no choice because "floating palaces belching forth clouds of sooty smoke have chased the white-winged and the red-winged pleasure boats of the era of the Spanish main from the seas and ports of most of the world."[54] By the 1920s Los Angeles's San

Pedro Harbor had lost its old shacks along the breakwater and was already a vast industrial wasteland filled with oil derricks, while further south, Laguna Beach had no marina, and Newport had just one cannery. Possibly because of its rarity, the cannery's single dilapidated structure drew numerous *plein-air* artists, including George Brandriff and Thomas Hunt.

Northern California, by contrast, was fortunate in having the late 19th-century sardine canneries of Monterey Bay, which were still thriving in the 1920s. E. Charlton Fortune and Armin Hansen made a specialty of painting the teeming wharves. Hansen focused primarily on Monterey's colorfully clad Sicilian and Portuguese fishermen. Unlike the works of most of his *plein-air* contemporaries, Hansen's paintings usually present a clear narrative, with his protagonists vigorously working the docks or braving the elements at sea.[55] "Everything that I have done," he once declared, "has always been to go back to the water and the men who gave it romance."[56] Even Hansen's unpopulated scenes contain drama. *Making Port* (Cat. No. 24), for example, depicts a storm-tossed tug forging courageously ahead to meet an incoming ship.

Cat. No. 24
Armin Hansen (American, 1886-1957)
Making Port, n.d.
Oil on canvas
30 x 32 inches
Joan Irvine Smith Collection

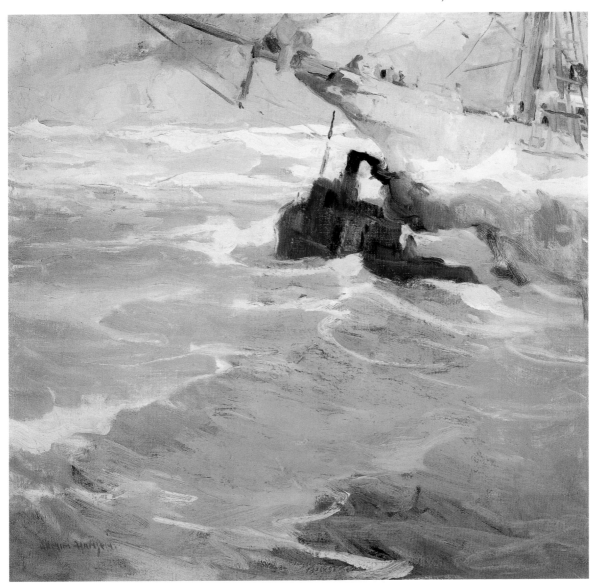

That farming, like fishing, could suggest romance and nostalgia probably accounts in good part for the prevalence of the theme in California Impressionism. If the rural pastorale was a staple of the French Barbizon School painters, it became an obvious choice for artists in California. Tree-shaded farmhouses, orchards in bloom, and horses grazing on sunny hillsides give their paintings an atmosphere of bucolic serenity, suggesting that California was, as Charles Frederick Holder observed, the perpetual "land of the afternoon."[57] Much as Millet, Corot, and Daubigny had done in the 19th century, the Californians portrayed a world in which humanity lived in harmonious intimacy with the land. The barns are uniformly weathered and the farms invariably small. This is a Jeffersonian vision of agrarian life, where an individual could achieve self-sufficiency, peace, and prosperity.

In portraying farming as a simple, pastoral mode of existence, the *plein-air* artists expressed their longing for an uncorrupted, pre-industrial California. This was not an exercise merely in nostalgia, but in wishful thinking, for the world of "Jim Smith's farm" was sadly far from the reality of Southern California.[58] By the 1920s most of the land had fallen into the hands of a few monopolies, making it extremely difficult for an individual family to own a farm. As Kevin Starr has pointed out, California agriculture was a business, not a way of life, and it was a business owned "either by corporations in San Francisco or Los Angeles, or by local elites who from the 1920s onwards appear in county histories as prosperous businessmen in suits and ties…" Meanwhile, the actual farm work was done by hired hands, which, in the Southland, meant mostly poor Mexicans "standing in cold muddy fields to pick broccoli in the winter, or in the summer bending down under a blistering sun over a short-handle hoe to clear weeds from endless rows of lettuce, cabbage, asparagus, and beets."[59] "Factories in the field" was Carey McWilliams's fitting description of the impersonal style of corporate agriculture practiced in Southern California while the Impressionists were turning out their confectionary Arcadias.[60]

It was not only the agrarian landscape that was showing signs of expanding industrialization; the commercial growth of Southern California during the 1910s and 1920s can only be characterized as staggering (Fig. 13). The subdivisions that sprang up throughout greater Los Angeles were literally unable to accommodate the thousands of people who poured into the region every month. Entire cities appeared seemingly overnight, the collaborations of city planners, real estate developers, and transportation corporations. The decade 1920-1930 alone witnessed the creation of Bell, Ventura, Lynwood, Torrance, Hawthorne, Tujunga, and numerous other communities. Many of these newly erected cities, despite all evidence to the contrary, were advertised as possessing the charm of quaint European villages. Even before construction was finished, Palos Verdes was promoted as "an old Spanish town, with arcaded walks, balconies, and winding stairways…."[61] The seaside town of Venice went so far as to emulate the Italian original, complete with a series of interconnecting canals and a fleet of gondolas imported from Europe.[62]

Such attempts at feigning Old-World charm were nothing short of burlesque considering that Los Angeles was, as the Chamber of Commerce so often liked to point out, one of the most modern cities in America. It was the first in the country, possibly in the world, to be illuminated entirely by electric lights.[63] In the 1920s Los Angeles had more telephones, more automobiles, and more miles of graded streets than any comparably sized city in the United States.[64] The explosive growth of the region's "overnight suburbs" was largely due to the fact that, by 1925, every other

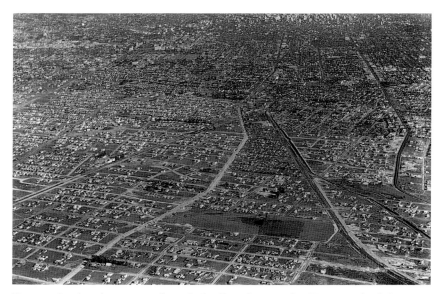

Figure 13 Los Angeles, 1926, east from Ogden Drive between San Vicente and 16th Street
Photograph, Spence Air Photograph Collection,
UCLA Department of Geography Air Photo Archives

Angeleno owned an automobile, enabling a lengthy work commute.[65] As one might expect, the modern freeway originated in Los Angeles as the brainchild of the Automobile Club of Southern California. The freeway was the centerpiece of the Club's fantastic scheme of turning Los Angeles into an ultramodern "autopia" that would forever eliminate traffic problems.[66] Congestion, however, only increased, and the freeways ultimately cemented over many of the region's most beautiful sights, including sections of the wooded Arroyo Seco, a sacred haunt of the California Impressionists.

The California *plein-air* artists left few recorded verbal responses to the helter-skelter destruction of land that was occurring around them at such an uncontrollable rate. We do not know, for example, how the Pasadenans Bischoff, Brown, Rose, Clark, or the Wachtels felt about the city's controversial decision in 1924 to plunk the Rose Bowl stadium in the middle of the Arroyo Seco along with a parking lot and asphalt roads. In Laguna Beach the artists evidently took an active role in holding the developers at bay during the early 1920s. According to one account, Frank Cuprien refused $75,000 for his ocean-front property with the question, "Where would I live?"[67]

Fred Hogue's writings in the *Los Angeles Times* indicate that, whether or not the artists expressed themselves publicly, they were painfully aware of the unchecked commercial sprawl, and their art was in good part a direct and deeply felt response to it. Hogue reported in 1926, "A score of landscapists and genre painters are writing the contemporary history of the first half of the twentieth century in Southern California. The groves they paint will disappear. The Laguna of today will not be that of tomorrow. The encroachments of trade and commerce will destroy the primitive beauty of some of the enchanted spots in the Southland; and the generations which come after will turn to these canvases as the records of a departed epoch."[68]

Kleitsch was among the artists who consciously set out to memorialize on canvas the swiftly passing beauty of Southern California's landscape. Kleitsch's paintings of Laguna Beach, executed in the 1920s, record the idyllic village on the verge of rapid development. Hogue, after visiting Kleitsch's studio in Los Angeles, commented that as early as 1928, paintings such as *Old Laguna* (1924) (See Fig. 10) portrayed a lost era, one

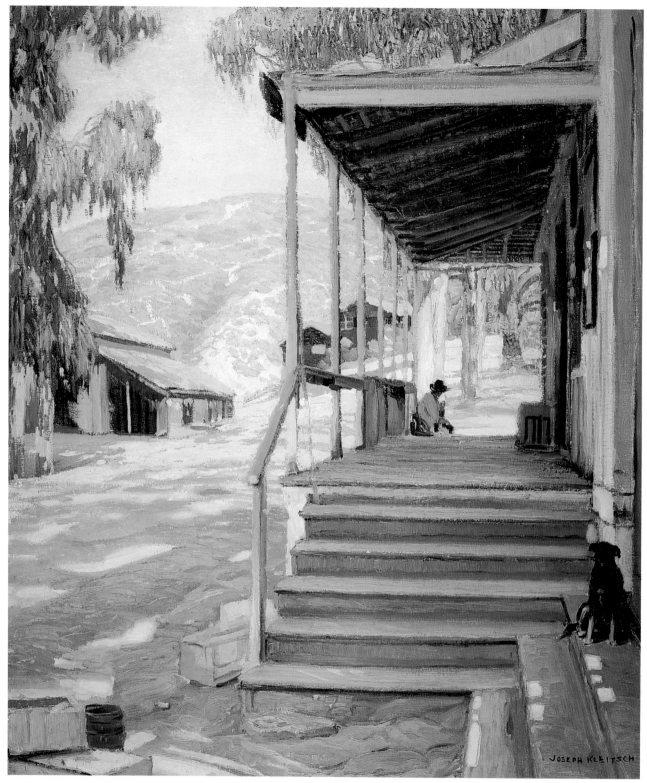

Cat. No. 32 Joseph Kleitsch (American, 1886-1931)
The Old Post Office, 1922
Oil on canvas
40 x 30 inches
Laguna Art Museum,
gift of Mrs. Joseph Kleitsch

that "lives only in memory, the Laguna before the subdividers came. The palms that cast their shadows across the winding street have been uprooted; the buildings have been demolished, to make way for modern progress. What the artists call desecration the realtors call improvement."[69] Kleitsch's *The Old Post Office* (Cat. No. 32) demonstrates how swift this desecration could be. Less than a year after the artist painted the board-and-batten building, it was razed to clear the way for the construction of 50 modern cottages and apartments.[70]

Wendt, whose canvases were almost misanthropic in their avoidance of human presence, took a similar preservationist view. A reticent and deeply private man, Wendt became something of a recluse after moving to Laguna Beach in 1912. He did, however, confide to Hogue about his profound aversion to commercial development, telling the journalist that "the splendor of Los Angeles and the seductive charm of Hollywood repel him." Hogue reported that Wendt was continuously seeking refuge from human encroachment: "When the builders come to slay the trees and scar the flowering slopes with roads and houses, he moves on to a deeper seclusion."[71]

Wendt appears to be the only California Impressionist to confront the destruction directly in his art. Most of his paintings are eulogies of pristine wilderness, but in *Vandalism* (1916) the dream has been betrayed. Here, Wendt's Edenic landscape has become a cemetery; the tree stumps suggest tombstones, and the stack of lumber a pile of corpses. This is a powerful indictment of modern society's violation of nature, which in Wendt's view, constituted a sacrilege of God's work.[72]

A small number of painters took an optimistic view of development. Accommodation can be found, for example, in Alfred Mitchell's *Summer Hills* (Fig. 14), which makes suburban growth in Southern California's hillsides look as natural as chaparral. Sam Hyde Harris managed to turn blighted industrial scenes into visions of enchantment. *Todd Shipyards, San Pedro* (Cat. No. 26) bathes the polluted harbor in deli-

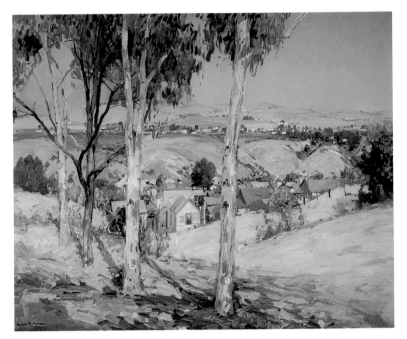

Figure 14 Alfred Mitchell
Summer Hills, 1929
Oil on canvas
40 x 50 inches
The Fleischer Museum

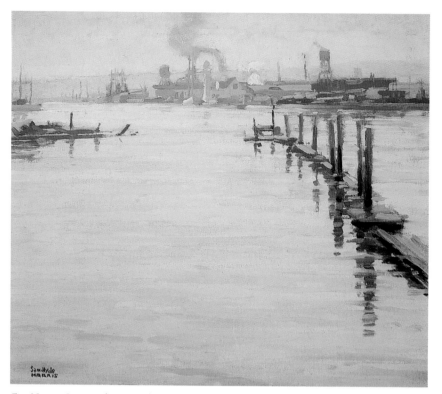

Cat. No. 26 Sam Hyde Harris (American, 1889-1977)
 Todd Shipyards, San Pedro, n.d.
 Oil on canvas
 20 x 23 inches
 Joan Irvine Smith Collection

cate tints of yellow and gray, suggestive of the region's heavy smog. The canvases Wendt painted in the 1940s toward the end of his life seemed resigned to the human imprint on the land. Dry and astringent in drab browns and greens, they maintain a peculiar beauty. As the art historian Everett C. Maxwell discerned, Wendt has "caught and portrayed the strange brooding melancholy that hangs like a pall over our southern landscape — a saddened landscape made mellow and lovely through heartache and disappointment."[73]

Most *plein-air* artists responded to the frenzied, headlong transformation of the land by turning their backs on it. Earlier Impressionists had welcomed, even celebrated, contemporary change. Trains, boats, newly constructed factories, and other signs of modernity were central to the iconography of the French. While the East-coast painters J. Alden Weir, Theodore Robinson, and John H. Twachtman preferred to paint their country retreats, they did not neglect to paint industrial themes.[74] Even Hassam, who abhored city life, considered it an article of faith to record his own epoch.[75] By contrast, the Californians consistently suppressed, altered, or abridged the actualities of their time. Beauty above truth was their philosophy, a reversal of the contemporary Ashcan School's credo. Through elision and euphemism, they created a world that was at once escapist and reassuring, a visual relief from the unpleasant realities of contemporary life.

Notes

1. Michael P. McManus, "A Focus on Light," in Patricia Trenton and William H. Gerdts, *California Light: 1900-1930* (Laguna Beach and San Francisco: Laguna Art Museum in association with Bedford Fine Arts, 1990), 13.

2. "Indian summer" is McManus's term, *ibid.* Impressionism first appeared in Southern California in the 1890s, but it was rare in Los Angeles before the early teens; for a precise chronology, see Nancy Dustin Wall Moure, "Impressionism, Post-Impressionism, and the Eucalyptus School in Southern California," in Ruth Lilly Westphal, *Plein Air Painters of California: The Southland* (Irvine, California: Westphal Publishing, 1982), 5-6. I have used the term "plein air" throughout this essay to refer to painting that was done directly from nature, but not necessarily in one sitting. Many of these paintings were completed in the studio.

3. Antony Anderson, *Los Angeles Times*, 19 November 1916. Mabel Urmy Seares concurred when she declared that "not until the advent of broken color, brilliant contrasts and direct painting from nature in its modern high key has…the southern part of the State found true interpretation." See Seares, "Modern Art and Southern California," *American Magazine of Art* (December 1917): 58.

4. The date usually given for San Francisco's introduction to Impressionism is 1894, at the California Midwinter Exposition; see, for example, William H. Gerdts, *American Impressionism* (New York: Abbeville Press, 1984), 255.

5. Steven A. Nash, *Facing Eden: 100 Years of Landscape Art in the Bay Area* (San Francisco and Berkeley: The Fine Arts Museums of San Francisco and University of California Press, 1995), xvi.

6. See for example, "California as a Sketching Ground," *International Studio* (April 1911): 121-131; William Howe Downes, "California for the Landscape Painter," *American Magazine of Art* (December 1920): 491; and Frederick R. Miner, "California, the Landscapist Land of Heart's Desire," *Western Art* (June-August 1914): 31-34.

7. William H. Gerdts, "To Light the Landscape," in Trenton and Gerdts, *California Light*, 31.

8. Mabel Urmy Seares, "Richard Miller in a California Garden," *California Southland* (February 1923): 10.

9. Harvey L. Jones, "Introduction: A Time and Place," in *A Time and Place: From the Ries Collection of California Painting* (Oakland: The Oakland Museum, 1990), 5.

10. Will South, "Guy Rose (1867-1925): An American Impressionist," in Will South, *Guy Rose: American Impressionist* (Oakland and Irvine, California: The Oakland Museum and The Irvine Museum, 1995), 60.

11. Carey McWilliams, *Southern California: An Island on the Land* (Salt Lake City: Gibbs Smith, 1946; reprint, 1994), 249.

12. Bram Dijkstra, "The High Cost of Parasols: Images of Women in Impressionist Art," in Trenton and Gerdts, *California Light*, 33-34.

13. McWilliams, *Southern California*, 118.

14. The statistics tell the story. Between 1900 and 1924 the population grew seventeen-fold, from 102,000 to 1,750,000. From 1920 and 1924 at least 100,000 people a year flooded into Los Angeles alone. Within the year 1924 developers subdivided 84,000 new lots and built 125,000 houses in the Los Angeles metropolitan area.

15. *Hotel Greeters Guide and Hotel Directory of California* (Los Angeles: Hotel Clerks of Los Angeles and Vicinity, 1926), 13. Ephemera Box 18-A, Pasadena Historical Museum.

16. McWilliams, *Southern California*, 210.

17. Ann Scheid, *Pasadena: Crown of the Valley: An Illustrated History* (Northridge, California: Windsor Publications, 1986), 147.

18. Charles Nordhoff, *California for Health, Pleasure, and Residence: A Book for Travellers and Settlers* (Harper and Brothers, 1882), 87. See Nordhoff's chapter, "Southern California for Invalids," 77-88.

19. See McWilliams, 96-101. One enthusiast, Dr. William A. Edwards, concluded that Southern California's unique climate could relieve and possibly cure the following ailments: incipient phthisis, chronic pneumonia, tuberculosis, disease of the liver, jaundice, functional female disturbances, the organic ills of advanced years, simple congestion of constipation, hepatic catarrh, insomnia, and enlarged glands.

20. Kevin Starr, *Inventing the Dream: California Through the Progressive Era* (New York: Oxford University Press, 1985), 91.

21. Starr, *Inventing the Dream*, 76.

22. George Wharton James, *California Romantic and Beautiful* (Boston: The Page Company, 1914), 272-73.

23. Mabel Urmy Seares, "The Spirit of California Art," *Sunset* (September 1909): 266.

24. Hector Alliot, "Primitive Art in Southern California," in *Art in California: A Survey of American Art with Special Reference to Californian Painting and Sculpture and Architecture Past and Present Particularly as Those Arts were Represented at the Panama-Pacific International Exposition* (San Francisco: R. L. Bernier Publishers, 1916; reprint, Irvine, California: Westphal Publishing, 1988), 47.

25. Ruth Westphal, *Plein Air Painters of California: The Southland* (Irvine, California: Westphal Publishing, 1982; reprint, 1990), 209.

26. Fred S. Hogue, "Edgar Alwyn Payne and His Art," in *Edgar Alwyn Payne and his Work* (Los Angeles: Stendahl Art Galleries, 1926), 15.

27. Fred Hogue, review, *Los Angeles Times*, 22 May 1927.

28. Redmond, quoted in Mary Jean Haley, "Granville Redmond: A Triumph of Talent and Temperament," in *Granville Redmond* (Oakland: The Oakland Museum, 1989), 17.

29. Jean Stern, Janet Blake Dominik, and Harvey L. Jones, *Selections from The Irvine Museum* (Irvine, California: The Irvine Museum, 1992), 103.

30. Jean Stern, *Alson S. Clark* (Los Angeles: Petersen Publishing Company, 1983), 37.

31. South, *Guy Rose*, 64.

32. Hazel Boyer, "A Notable San Diego Painter," *California Southland* (April 1924): 12.

33. C. R. Pattee, D.D., "The Land of Sunshine," (excerpt) *Land of Sunshine* (June 1894): 13.

34. The term was coined by Frederick J. Teggart, in his essay, "The Education of the Adult," *Philopolis* (25 June 1907): 3-4; see Nancy Boas and Marc Simpson, "Pastural Visions at Continent's End: Painting of the Bay Area 1890 to 1930," in Nash, *Facing Eden*, 53.

35. Joachim Smith, "The Splendid, Silent Sun: Reflections on the Light and Color of Southern California," in Trenton and Gerdts, *California Light*, 89.

36. Hogue, "Edgar Alwyn Payne and His Art," in *Edgar Alwyn Payne and His Work*, 14.

37. Edgar A. Payne, *Composition of Outdoor Painting* (Hollywood: Seward Publishing Company, 1941), 39.

38. Wendt quoted in Alma May Cook, "Showing of Thirty-five William Wendt Paintings Art Event of Week," *Los Angeles Herald-Express*, 25 March 1939.

39. John Alan Walker, *Documents on the Life and Art of William Wendt (1865-1946), California's Laureate of the Paysage moralisé* (Big Pine, California: John Alan Walker, Bookseller, 1992), 76.

40. *Ibid.*, 44.

41. Antony Anderson, *Los Angeles Times*, 8 April 1917, quoted in Janet Blake Dominik, "Patrons and Critics in Southern California, 1900-1930," in Trenton and Gerdts, *California Light*, 174.

42. See *Edgar Payne, 1882-1947* (Los Angeles: Goldfield Galleries, 1987), n.p.

43. *Ibid.*

44. *Laguna Beach, California*, pamphlet, published by Laguna Beach Chamber of Commerce, n.d. In archives of the Laguna Art Museum, Laguna Beach.

45. Susan Landauer, "Searching for Selfhood: Women Artists of Northern California," in *Independent Spirits: Women Painters of the American West, 1890-1945*, Patricia Trenton, Ed. (Los Angeles and Berkeley: Autry Museum of Western Heritage in association with University of California Press, 1995), 23.

46. Merle Armitage, review, *West Coaster* (1 September 1928).

47. Jean Stern, "John Gamble," in *Plein Air Painters of California: The North*, Ruth Westphal, Ed. (Irvine California: Westphal Publishing, 1986), 76

48. *A Time and Place*, 34.

49. *Ibid*, 28.

50. Nash, *Facing Eden*, 44.

51. McWilliams, *Southern California*, 73.

52. Starr, *Inventing the Dream*, 88.

53. See Pamela Hallan-Gibson, "Mission San Juan Capistrano," *Romance of the Bells: The California Missions in Art* (Irvine, California: The Irvine Museum, 1995), 45-71.

54. Fred S. Hogue, "The Art of Edgar Alwyn Payne," *Los Angeles Times*, 23 May 1926.

55. Of all the artists discussed in this essay, Hansen diverges most sharply from orthodox Impressionism. As Charlotte Berney has observed, his art defies easy classification. It is Impressionist in his uninhibited brushwork, but not in its lack of concern for the effects of light. See Berney, "Steering a Course: The Art of Armin Carl Hansen," in *Armin Hansen: The Jane and Justin Dart Collection* (Monterey, California: Monterey Peninsula Museum of Art, 1993).

56. The Dorian Society, *Kern County Collects: The California Landscape* (Bakersfield, California, California State University, Bakersfield, 1990), n.p.

57. Starr, *Inventing the Dream*, 100.

58. "Jim Smith's Farm" is the title of a painting by Sam Hyde Harris, c. 1940.

59. The Dorian Society, *Kern County Collects*, 173.

60. This is the title of Carey McWilliams's classic study of farm labor published in 1939.

61. Back cover, *California Southland* (February 1924).

62. McWilliams, *Southern California*, 130-31.

63. *Ibid.*, 129.

64. By 1915, Pasadena claimed to have more automobiles per capita than any other city in the world; see Scheid, *Pasadena*, 116.

65. Scott A. Bottles, *Los Angeles and the Automobile: The Making of the Modern City* (Berkeley: University of California Press, 1987), 92.

66. *Ibid.*, 216.

67. Elizabeth Bingham, "Art Exhibits and Comments," *Saturday Night* (Los Angeles), 1 September 1923.

68. Hogue, "The Art of Edgar Alwyn Payne," *Los Angeles Sunday Times*, 23 May 1926.

69. Fred S. Hogue, "A Hungarian Artist," *Los Angeles Times*, 25 October 1928.

70. Patricia Trenton, "Joseph Kleitsch," in Laguna Art Museum, *75 Works, 75 Years: Collecting the Art of California* (Laguna Beach, California, 1993), 36.

71. Quoted in "William Wendt 1865-1946," *Southwest Art* (June 1974): 43.

72. For a Christological analysis of this painting, see Walker, *Documents on the Art and Life of William Wendt*, 17-23. *Vandalism* is pictured on the cover.

73. Unidentified clipping, ca. 1947, Laguna Art Museum archives.

74. This is not to say that the Eastern Impressionists did not traffic in nostalgia; see H. Barbara Weinberg, Doreen Bolger, and David Park Curry, with the assistance of N. Mishoe Brennecke, *American Impressionism and Realism: The Painting of Modern Life, 1885-1915* (New York: The Metropolitan Museum of Art, 1994), 51-55.

75. *Ibid.*, 4.

Cat. No. 12 Colin Campbell Cooper (American, 1856-1937)
 Two Women, n.d.
 Oil on board
 24½ x 21½ inches
 Joan Irvine Smith Fine Arts, Inc.

FROM GIVERNY TO LAGUNA BEACH

Donald D. Keyes

MERICAN IMPRESSIONISM WAS BUT ONE ASPECT OF A BROADER INVESTIGATION INTO light that covered the latter half of the 19th century. This interest contributed to a change in the principal subject of art from the fixed and ideal to the momentary and fluctuating. During the period from about 1885 until the outbreak of World War I, Americans experienced a completely new way of life, from the introduction of electricity to general acceptance of Darwin's theory of evolution. While historians often characterize the *fin de siècle* as the Gilded Age or the Gay '90s, the accumulation of incredible wealth (Fig. 1) often led to profound corruption and the growth of a huge underclass. During this period of rapid change, Impressionism emerged as a world-wide phenomenon, from Moscow to Los Angeles. The California chapter of Impressionism's evolution is the style's final installment.

The first American Impressionists worked alongside painters who developed an interest in light in Munich or through the painters of the Barbizon School. Many of these painters are today called Tonalists, and George Inness typifies the group. In the mid-1880s not long after the general acceptance of Tonalism, American artists began discovering French Impressionism, with its broader introduction into America taking place in the next decade.[1] Not many years thereafter the realist painters in the circle of Robert Henri (later called the Ashcan School) moved from Philadelphia to New York and began to assault high-brow academic art. American Impressionism experienced its greatest success in the East just as Modernism made its appearance in America, notably at the Armory Show of 1913.[2] The complexity of American painting between 1885 and 1915 reflects the situation throughout the arts in America as well as in society as a whole. From the suffragette movement to the establishment of the Ku Klux Klan, this was a time of rapid change. Examples of the amazing range of new art forms include the dancing of Isadora Duncan, architecture of Frank Lloyd Wright, and music of Charles Ives.

During the late 1880s French Impressionism was being presented in New York and Boston by art dealer Paul Durand-Ruel and American painter Mary Cassatt and her friend Louisine Elder Havemeyer. But the road to acceptance was neither straight nor easy. At first Americans distinguished between acceptable landscapes while dismissing figure scenes which often seemed lewd and too familiar. Pretty landscapes with few people found the most buyers (Cat. No. 30), while images depicting women doing the laundry or people drinking remained largely unsold.

Three years before the last exhibition of the French Impressionists, in 1886, Claude Monet had built a secluded studio and home in the hamlet of Giverny. He later created his floral fantasy, complete with Japanese bridge, and subsequently established the tenets of late Impressionism. By 1889 the first wave of American artists was firmly planted in Giverny.[3] Although few actually knew Monet, in part because they could not speak French very well, his paintings had a profound and lasting effect on their artistic maturation. By the early 1890s an international colony had taken root in Giverny, with American painters in the vanguard. The second wave of American artists arrived soon thereafter and included a large number of women.

Figure 1 Meta Cressey (American, 1882-1964)
Under the Pepper Tree, n.d.
Oil on canvas
35½ x 40½ inches
Joan Irvine Smith Fine Arts, Inc.

The presentation of American *fin-de-siècle* culture and society at the mammoth World's Columbian Exposition in Chicago in 1893 illuminated its fundamental dualities: the urban and natural, the cosmopolitan and rural, the modern and academic, the individual and stereotype, the secular and sacred, the real and ideal. Imperialist in spirit, the Columbian Exposition affirmed Anglo-Saxon hegemony and superiority in the face of expanding racial diversity; it offered a vision of an ordered, corporate, modern society that seemingly resolved the social tensions of a disaffected world which was found only blocks outside the fairground's gates.[4] The 1880s and 1890s constitute a troubled period in American history. The changes that Anglo-American upper classes experienced produced more anxiety than excitement, and their pain is made more evident by revisiting the series of economic downturns and social displacements, as well as philosophical and religious crises.

The Chicago fair was to be America's aesthetic coming-out party, a declaration that in the fine arts, as in industrial production, she had come of age. Yet disparities

interfered with its success, and the art exhibition presented a Midway-like visual melange of styles and subjects. While sentimental and moralizing genre scenes such as Thomas Hovenden's conservative *Breaking the Home Ties* (1890, Philadelphia Museum of Art) won the public's highest approval, the young American followers of Monet's style were breaking new ground that soon led to a basic change in the visual arts.

American Impressionists often integrated styles and attitudes from various sources aside from those found in Paris. For many, the work of James Abbott McNeill Whistler was as important a model as that of Monet. John Twachtman, for example, one of the early adherents to Impressionism, studied in Munich and often blended Whistlerian Tonalism and Impressionism in his mature work. His presentation of a tranquil, civilized world — in contrast to the perceived savagery of French Impressionism — is precisely what American Impressionism held out to viewers in the 1890s. The formative group is the Ten American Painters, or The Ten, who exhibited together in New York and later Boston, starting in 1898 and continuing until 1918. Many of these artists often used a basically tonal mode which has only general affinities to French Impressionism in the breadth of its brushwork and high-keyed colors. This Tonalist mode continued to appear in the paintings of the Impressionists working in California as well.[5] Based on tonal harmonies, much of American Impressionism constituted a vision that offered reassurances to the most pressing questions of the day, unlike the art of the French Impressionists, a soothing and ordered realm far

Cat. No. 30 William Lees Judson (American, 1842-1928)
 Arroyo Seco with Bridge, n.d.
 Oil on board
 18 x 30 inches
 Joan Irvine Smith Fine Arts, Inc.

removed from the turmoil of the real world (Cat. No. 13). In the face of the Darwinian transformation of nature and the political and economic strife in human society at the turn of the century, it seemed that the individual's harmonious relation with nature had been lost in the modern industrial world. What was wanted from art was a reassurance that harmony and unity could be recovered for both the individual and the community.

Impressionism blossomed in America during the 1890s, culminating in 1898 with the exhibition of The Ten. This heterogeneous band of Eastern painters coalesced at the same time as the style was internationalized. In nearly every manifestation its French progenitors' sociological and political subtexts were replaced by more conservative expressions.

Following Impressionism's international development, the initial community in Giverny expand into a third generation. These American painters were mainly figure painters, many of whom played significant roles in the establishment of Impressionism in California. Most of its members were native Midwesterners, generally trained

Cat. No. 13 Colin Campbell Cooper (American, 1856–1937)
Pergola at Samarkand Hotel, Santa Barbara, c. 1921
Oil on canvas
29 x 36 inches
Joan Irvine Smith Fine Arts, Inc.

in Chicago, whose decorative Impressionism was monumental and filled with figures, mostly women in gardens or interiors. Alson Clark, Frederick Frieseke, John Frost, Richard Miller, Lawton Parker, and Guy Rose formed the core of this group (Cat. No. 47). Their modernist approach emphasized the decorativeness of the subject, with acknowledgement of the importance and popularity of Japanese art. Ironically, despite the use of women as frequent subjects by these artists while they were living in Giverny, most of the artists were enamored of the magnificent landscape they found in California. Guy Rose is a particularly apt example of this change from his earlier period, exemplified by *The Green Parasol* (Cat. No. 46), to his later years in California, as exemplified by *Point Lobos* (Cat. No. 48).

Clark's career demonstrates the intricate web that constitutes American Impressionism and that forms the basis for the style's propagation in California. The two most important influences on his work were Whistler and William Merritt Chase. After studying nearly two years at the Art Institute of Chicago, Clark went to New

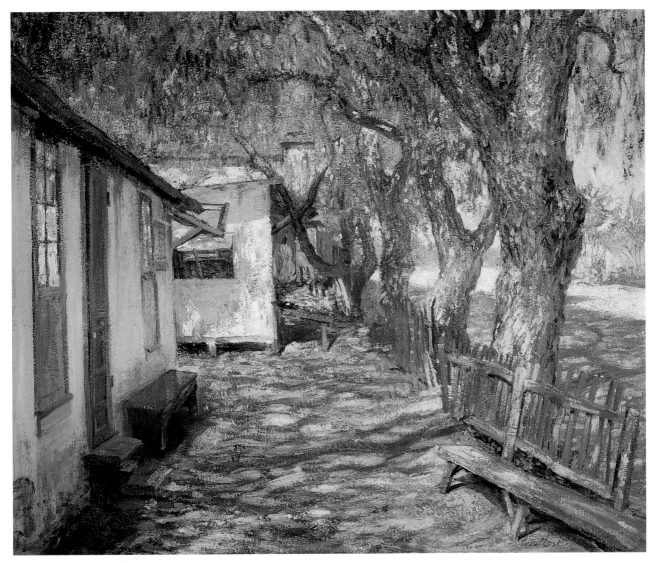

Cat. No. 47 Guy Rose (American, 1867-1925)
 San Gabriel Road, c. 1914
 Oil on canvas
 24 x 29 inches
 Joan Irvine Smith Fine Arts, Inc.

York in the fall of 1896, where he entered Chase's school. Chase, aside from being an innovative painter, was one of the most engaging and inspiring teachers of the era. Clark studied with Chase in his classes in New York and Shinnecock, Long Island.

Along with several of his classmates, Clark traveled in Europe, first to London and then to Paris. Whistler's influence on him was profound during this period. Clark then returned to America, where he had some success at the Art Institute of Chicago exhibiting paintings in his Whistlerian mode. In 1910 he returned to Europe, where he joined the third generation of painters in Giverny until he was forced to leave France because of the mobilization leading up to World War I. These intertwined associations between Giverny, New York, the Midwest, and California played out in many ways during the first decades of the 20th century.

Clark's colleague in Giverny, Guy Rose (Cat. No. 49), returned to America in 1912 and exhibited at the MacBeth Gallery in New York, the same gallery Robert Henri and his band of rebels exhibited their shocking images of urban life in 1908.[6] Two years later, Rose returned to California. He found a small, but active community of artists in the Los Angeles area, including the painters William Wendt (Cat No. 58), the Wachtels (Cat. Nos. 54 and 55), and Hanson Puthuff (Cat. No. 38). His arrival coincided with a general beginning of the region's art scene, that is some 15 or 20 years after the Eastern artists were working in a "modernist," i.e. Impressionist, mode.

These young Impressionist painters worked in marked contrast to the art establishment in Northern California, dominated by the Tonalist aesthetic, spurred on by William Keith and George Inness, who visited San Francisco in 1891, and the California Decorative Style and its parent Arts and Crafts Movement. Arthur F. Mathews was the principal champion of this aesthetic. Most of Mathews's paintings and those of his followers contained flat forms, almost like wooden mosaics, arranged in a Japanese inspired Art-Nouveau pattern (Cat. No. 42).

Rose left New York just before the clamor for modernism culminated in the famous Armory Show in 1913. As a result of this concurrent interest, many of his younger Californian contemporaries incorporated fairly abstract elements into their work. Kleitsch, in *The Oriental Shop* (Cat. No. 31), demonstrates a modernist aesthetic that Seldon Gile, in *Boat and Yellow Hills*, developed into a full-blown modernism. These examples notwithstanding, California Impressionists generally extended the example of their colleagues on the East Coast: their scenes are devoid of people and filled with harmonious forms and colors, creating a respite from the world's tensions and unpredictable events. Los Angeles-based critic Anthony Anderson scoffed at their paintings as nothing but "sweetness and light"(Cat. No. 14).[7]

Summer art colonies were a relatively new phenomenon of the late 19th century. They were also important centers for the dissemination of Impressionism. As a result of more leisure time for the upper-middle and middle classes and new and better forms of transportation, rural areas became more accessible, and art colonies began appearing. Along the East Coast many Impressionists were involved with such colonies, some of which were even permanent residences. Often art classes vied with tennis and golf, but some serious instruction took place. In Shinnecock, Chase held sway over legions of summer students, with similar communities appearing across the country. In Brown County, Indiana, artists, many of whom had been trained at the Art Institute of Chicago, gathered to create the Hoosier School. From Pennsylvania to Arkansas, Impressionism had become the principal national style and its basic breeding ground was the art colony, with its *plein-air* painting.

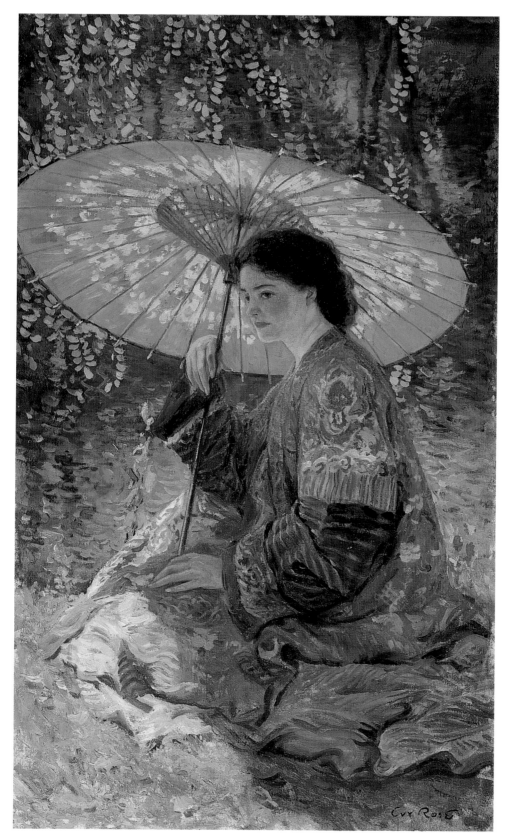

Cat. No. 46 Guy Rose (American, 1867-1925)
 The Green Parasol, c. 1909
 Oil on canvas
 31 x 19 inches
 Collection of Patricia and John Dilks

Cat. No. 49 Guy Rose (American, 1867-1925)
The Model, c. 1919
Oil on canvas
24 x 20 inches
The Buck Collection

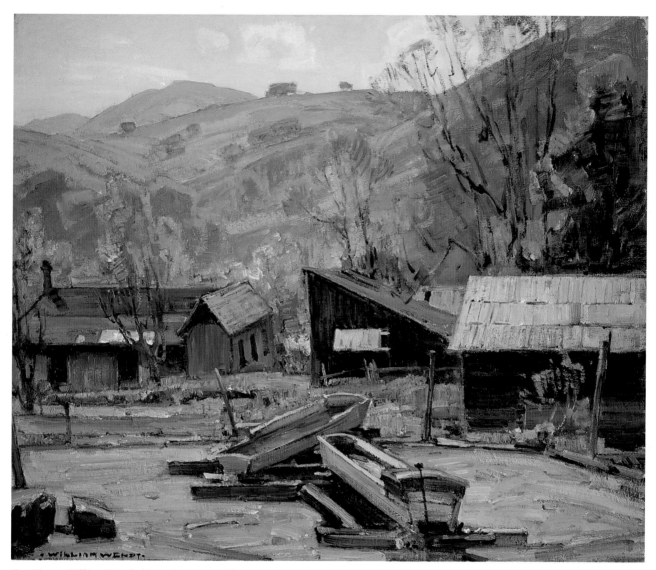

Cat. No. 58 William Wendt (American, 1865-1946)
 Untitled Landscape, n.d.
 Oil on canvas
 25 x 30 inches
 Joan Irvine Smith Fine Arts, Inc.

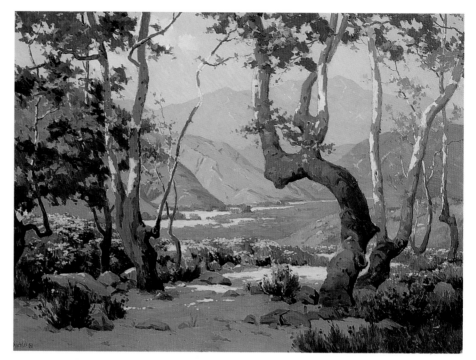

Cat. No. 54 Elmer Wachtel (American, 1864-1929)
Golden Autumn, Cajon Pass, n.d.
Oil on canvas
22 x 30 inches
Joan Irvine Smith Fine Arts, Inc.

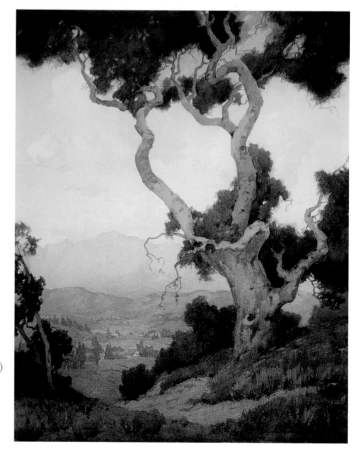

Cat. No. 55 Marion Wachtel (American, 1876-1954)
Untitled Landscape, n.d.
Watercolor and pastel on paper
19½ x 15½ inches
Joan Irvine Smith Fine Arts, Inc.

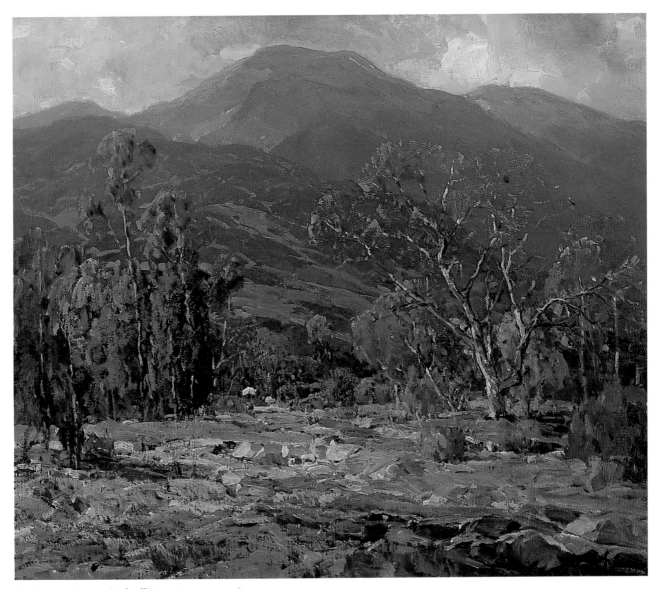

Cat. No. 38 Hanson Puthuff (American, 1875-1972)
 Transient Shadows, c. 1926
 Oil on canvas
 26 x 30 inches
 The Buck Collection

Cat. No. 42 John Hubbard Rich (American, 1878-1955)
 The Idle Hour, 1917
 Oil on canvas
 14 x 14 inches
 The Irvine Museum

Cat. No. 31 Joseph Kleitsch (American, 1886-1931)
 The Oriental Shop, 1925
 Oil on canvas
 32 x 26 inches
 Joan Irvine Smith Fine Arts, Inc.

Cat. No. 14 Colin Campbell Cooper (American, 1856-1937)
Cottage Interior, n.d.
Oil on canvas
20 x 24 inches
The Henderson Collection

Aside from Pasadena's Arroyo Seco, Monterey and Laguna Beach were the two most important art colonies. In both, Impressionism was the dominant style. An early member of the Monterey colony, E. Charlton Fortune (Cat. No. 18), had been one of Chase's students in New York. At her behest Chase went to Monterey in 1914 to teach at the Carmel Summer School of Art.

The following year Chase's paintings occupied a one-person room at the Panama-Pacific International Exposition, making him one of only ten American artists so honored. The colossal exhibition declared the region's recovery from the devastating earthquake and fires of 1906 as well as the completion of the Panama Canal in 1914. It was the first major international art exhibition held in the state since the California

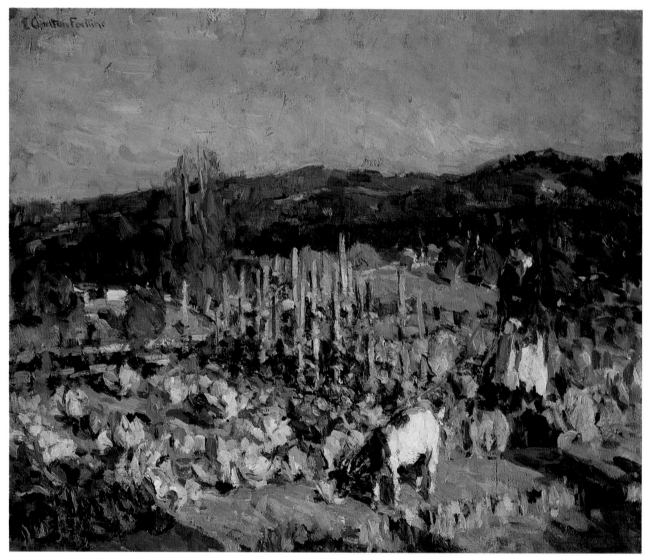

Cat. No. 18 E. Charlton Fortune (American, 1885-1969)
 The Cabbage Patch, c. 1914
 Oil on canvas
 20 x 24 inches
 Collection of Patricia and John Dilks

Midwinter International Exposition of 1894. As such it offered Northern Californians their first chance to see a large number of excellent Impressionist paintings from an array of international artists. Included in the exhibition were over 4,500 American paintings, providing a remarkable if not daunting survey of American art from the 18th century to that time.[8]

Even though academically oriented committees chose the work, the exhibition included modern European picures by Cézanne, Degas, Gauguin, Manet, Monet, Pissarro, Renoir, and Sisley. There were also works by artists who had exhibited in the Armory Show in 1913, such as the French Symbolists, and by the Italian Futurists, who had been excluded from the Armory Show.

The reception of Childe Hassam's work demonstrates how broadly accepted Impressionism had become by the time of the Panama-Pacific International Exposition. One of the other painters chosen to show in his own room, Childe Hassam was in San Francisco in 1914 to paint the mural *Fruits and Flowers* over the entrance to the Court of Palms in the Palace of Fine Arts. The exhibition of his work, which included 38 paintings from nearly all phases of his mature career, received warm, generous recognition of his position "as perhaps the leading performer in (Impressionism)..."[9]

Frederick Frieseke, who had eight paintings in the exhibition, received the grand prize. The selection of his works included several mildly salacious paintings of sprawling nudes outdoors covered only in dappled light which Eugen Neuhaus called "real Jewels of light and colour...Frieseke's clear, joyous art is typically modern, and expresses the best tendencies of our day."[10] A gauge of the kind of art being lauded at the time of the Panama-Pacific International Exposition can be demonstrated by two examples: John White Alexander's *Phyllis* (Fig. 2), and Ellen Emmet Rand, *In the Studio* (Fig. 3), which were featured prominently in Eugen Neuhaus's critical catalogue of the art exhibition. The Panama-Pacific International Exposition included a broad selection of work by women, including Rand, Mary Cassatt, and Lilian Westcott Hale. Depictions of women, such as Alexander Dennis Bunker's *The Mirror,* and Edmund Tarbell's *The Dreamer* now titled *Reverie (Katharine Finn),* also played an important role in the development of California Impressionism. This can also be seen in William Cahill's *Grandma's Gown* (Cat. No. 9), which clearly demonstrates the influence of the Boston School, notably Tarbell, on Californian painting.

The Giverny and Eastern influences were felt in other ways, especially in the paintings of women, as seen in the Cahill, and in the work of Colin Campbell Cooper. Best known for his architectural studies of New York and his native Philadelphia, Cooper exalted California's intense light through his dazzling brushwork and high-keyed colors. He settled in Santa Barbara in 1921, where he responded to the beauty of its gardens, as can be seen in his late *A California Water Garden at Redlands, California* of 1929 (Fig. 4). The Pennsylvania Impressionist George Gardner Symons, who had visited Southern California as early as 1884, returned there with his friend William Wendt, whom he had met while studying at the Art Institute of Chicago. For a while he lived in the newly established art community in Laguna Beach, where he painted *Irvine Cove, Laguna Beach* (Fig. 5). Symons soon left the area, but Wendt remained to establish what has been called the "Eucalyptus School," so called after the Australian Eucalyptus trees, which had been planted to help stabilize the region's fragile environment. By 1920 Laguna Beach was the southern equivalent of the north's Monterey art colony.[11]

Figure 2 John White Alexander
Phyllis, n.d.
Oil on canvas
86 x 44 inches
Sheldon Swope Museum of Art

Figure 3 Ellen Emmett Rand (American, 1876-1941)
 In the Studio, 1910
 Oil on canvas
 44¼ x 36¼ inches
 Benton Museum, Gift of John A., William B., and
 Christopher T.E. Rand

Cat. No. 9 William Vincent Cahill (American, 1878-1924)
Grandma's Gown, 1912
Oil on canvas
24½ x 20¼ inches
The Fleischer Museum

Not long after his return to California, Guy Rose started teaching at the Stickney Memorial School of Art in Pasadena, where he eventually became director in 1918. He also encouraged Clark and Miller, two of his friends from Giverny, to join him there. Miller stayed for two years, and Clark eventually became director of the school in 1921. Starting in 1908, John Frost lived in Giverny with his brothers and father, the renowned illustrator Arthur B. Frost. In 1919 he moved to Southern California and stayed on to teach at the Stickney School. The three, Clark, Frost, and Rose occasionally exhibited together in area galleries. In founding the Ten Painters of Califor-

Figure 4 Colin Campbell Cooper (American, 1856-1937)
A California Water Garden at Redlands, 1929
Oil on canvas
29½ x 36½ inches
The Fleischer Museum

nia they even imitated the example of the Ten American Painters when they exhibited together at the Kanst Gallery in Los Angeles.[12]

Painters came to California from all across America, but there were also painters who came from Europe and not from Giverny. Most were drawn by the excitement of the burgeoning economy, lured by the Panama-Pacific International Exposition, and assured of safety from the raging conflict in Europe. A large number of the new California Impressionists were from Europe, including Franz Bischoff from Austria, Maurice Braun and Kleitsch from Hungary, and Ritschel and Wendt from Germany.

Figure 5 George Gardner Symons
Irvine Cove, Laguna Beach
Oil on canvas
25 x 30 inches
The Fleischer Museum

Such was the strength of the movement that even the traditionalist Arthur Mathews succumbed, at least in part. His late paintings, such as *Monterey Cypress* of 1930 (Fig. 6), make use of local color and broken brushwork in order to convey the feeling of the light outdoors. But Mathews's conversion came well after Impressionism; in California and indeed the rest of the country, it had been put aside for more modern, abstracted art forms. The Society of Six, represented by Seldon Gile, got its start within the Impressionist mode but soon advanced far beyond the representation of physical place and easily understood forms into a world of intense colors and broken forms, expressive not of place but of art itself and the inner psyche; in other words a thoroughly modern art.

The period from 1893, the date of the Chicago fair, to 1915, the date of the San Francisco exposition, represents Impressionism's coming of age, first in New York and Boston, and finally, as it rolled across America, in California. During this time the style evolved into an original American art form, one which dominated painting from coast to coast as no other had since the Hudson River School.

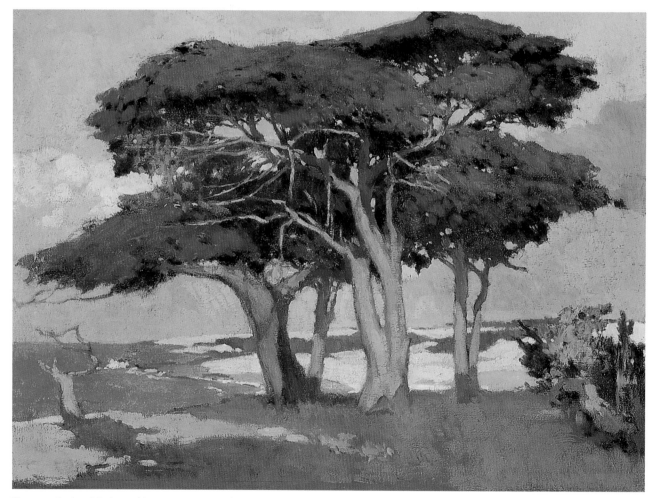

Figure 6 Arthur Mathews (American, 1860 - 1945)
 Monterey Cypress, 1930
 25½ x 29½ inches
 The Oakland Museum of California, gift of Concours d'Antiques
 Art Guild of the Oakland Museum Association

Notes:

1. Even though Inness was a vehement antagonist to the style, he and his fellow Tonalists were occasionally grouped together with the Impressionists. Samuel Isham in his 1905 history of American art grouped acknowledged Tonalists and the *plein-air* school of "so-called impressionism" in one chapter. As discussed below, Tonalism had a significant impact on generally recognized Impressionists, such as John Twachtman. The best treatment of this history remains William H. Gerdts, *American Impressionism* (New York: Abbeville Press, 1984).

2. See H. Barbara Weinberg, Doreen Bolger, and David Park Curry, *American Impressionism and Realism: The Painting of Modern Life, 1885-1915* (New York: The Metropolitan Museum of Art, 1994).

3. See William H. Gerdts, *Monet's Giverny: An Impressionist Colony* (New York: Abbeville Press, 1993) especially pp. 101-155.

4. Janice Simon, "The Promise of 1893," in *Crosscurrents In American Impressionism at the Turn of the Century* (Athens: Georgia Museum of Art, 1996), 3-4

5. See Harvey L. Jones, *Twilight and Reverie: California Tonalist Painting: 1890 - 1930* (Oakland, California: The Oakland Museum, 1995).

6. Armin Hansen is an example of a California artist who bridged the two modes, Impressionism and realism. In large part this amalgamated style is the result of his experience with the rough life of cowboys seen with his father, the illustrator H. W. Hansen, and his six years in Europe, where he saw first-hand the work of the Fauves and German Expressionists. His *Salmon Trawlers* demonstrates his affinity for the work of George Bellows as well as the French and German Expressionists in his strong contrasts, bold brushwork, and simplified forms.

7. Anthony Anderson, "The Realm of Art," *Los Angeles Times,* December 1, 1918.

8. Included in this survey was Hovenden's *Breaking the Home Ties*, the show-stopper from the 1893 Columbian Exposition in Chicago.

9. John E. D. Task, "The Department of Fine Arts at the Panama-Pacific International Exposition," *Art in California: A Survey of American Art with Special Reference to Californian Paintings, Sculpture and Architecture Past and Present Particularly as Those Arts Were Represented at the Panama-Pacific International Exposition* (1st edition 1916; reprint Irvine, California: Westphal Publishing Company, 1988), 84-5. Hassam had gone West in 1904 and subsequently four years later, in order to decorate the home of his friend and patron Colonel C. E. S. Wood. See Charles Eldredge, "American Impressionism Goes West" in *Crosscurrents in American Impressionism at the Turn of the Century,* (Athens, Georgia: Georgia Museum of Art, 1996), 111-112. Other painters from the East Coast who painted murals for various exposition buildings include William De Leftwich Dodge, Robert Reid, and Edward Simmons. See Hamilton Wright, "Mural Decorations at the Panama-Pacific International Exposition," *Art in California...*, 129-138. See also Christian Brinton, *Impressions of the Art at the Panama-Pacific Exposition, with a Chapter on the San Diego Exposition and an Introductory Essay on the Modern Spirit in Contemporary Painting* (New York: John Lane Co., 1916), 15-16, and John Caldwell, "California Impressionism: A Critical Essay," and Terry St. John, "California Impressionism After 1915," *Impressionism, The California View: Paintings 1890-1930* (Oakland, California: The Oakland Museum, 1981), n.p.

10. Eugen Neuhaus, *The Galleries of the Exposition: A Critical Review of the Paintings, Statuary and the Graphic Arts in the Palace of Fine Arts at the Panama-Pacific International Exposition* (San Francisco: Paul Elder and Company, 1915), 85.

11. The southern counterpart to the Panama-Pacific International Exposition was the Panama-California Exposition in San Diego. This exhibition marks the beginning of the city's professional artists' community, whose major artist was Maurice Braun, who often painted San Diego Bay.

12. The Kanst Gallery was one of the major contributors to the selection of California Impressionists' work at the Panama-Pacific International Exposition and had a strong association with the New York art market.

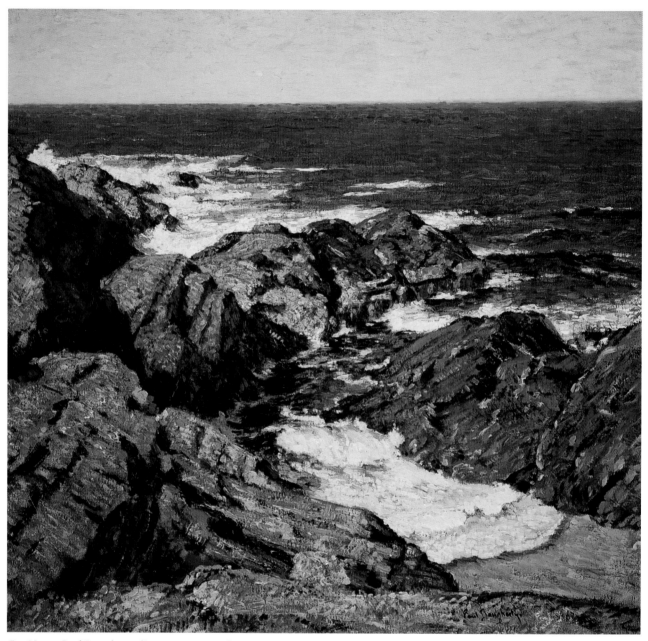

Cat. No. 16 Paul Dougherty (American, 1877-1947)
The Twisted Ledge, n.d.
Oil on canvas
34 x 36 inches
Joan Irvine Smith Fine Arts, Inc.

THE CALIFORNIA IMPRESSIONIST STYLE IN PERSPECTIVE

Jean Stern

CALIFORNIA HAS PRODUCED ARTISTS OF TREMENDOUS ABILITY WHOSE EXPER-imentation in a broad range of styles and media has resulted in a distinctly regional style. From the turn of the century until the start of the Depression, painting in California was dominated by a remarkable artistic style that combined several distinctive aspects of American and European art. Commonly called California Impressionism or California *plein-air* painting, this movement was concerned with the colors and the splendid light of the Golden State.

The Impressionism adopted by American painters in the late 1880s was a modified and somewhat tempered revision of the prototypical, French movement that originated in the late 1860s and was later popularized in the early 1870s. The significant contributions of French Impressionism to American art were in the use of color and specialized brushwork. The scientific theories of color, most notably those of the influential French chemist Eugène Chevreul, who published *Laws of Simultaneous Contrast of Colors* in 1839, were an aspect of Impressionism. Artists readily adopted these theories, and the resulting paintings possessed brilliant and convincing effects of natural light. The loose, choppy brushstroke characteristic of Impressionist painting was the consequence of both the quick paint application and the desire to produce a painted surface covered with a multitude of daubs of bright color. This profusion of small strokes of color simulated the effects of varying light conditions – particularly of fluid, brilliant sunlight (Cat. No. 29).

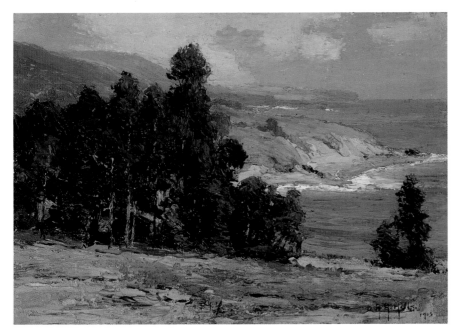

Cat. No. 29 Anna Hills (American, 1882-1930)
 July Afternoon, Laguna Beach, 1915
 Oil on canvas
 7 x 10 inches
 The Redfern Gallery, Laguna Beach, California

American Impressionism, in general, differed from its French roots in two notable ways. First, Americans preferred to retain a solid sense of form, as opposed to the French penchant for dissolving forms. The propensity for realistic representation remains constant throughout American painting, so much so that the American Impressionist style could easily be described as "Impressionistic realism." Second, American artists of the period preferred landscape and rural settings (Cat. No. 23), while many of the French portrayed city life and drew much of their inspiration from the occupational and recreational activities of the working class.

Coinciding with the advent of Impressionism in America in the mid-1880s, California experienced a period of rapid population growth. The opening of the transcontinental railway in 1869 made passage to San Francisco safer and quicker than the horse-drawn vehicle route or the tedious voyage either around South America or across Panama prior to the construction of the canal. A railroad opened between San Francisco and Los Angeles in 1876, and the Santa Fe Railway's all-weather route from Chicago to Los Angeles through the Southwest was completed in 1885. These led to the first of many successive land booms in Southern California. With the growth of population and commerce, Southern California began to attract and inspire professional artists in the 1880s.

Beginning in the Gold Rush era, residents of Northern California enjoyed a well-established art community within San Francisco's growing social and cultural community. Virgil Williams (1830-1886), William Keith (1839-1911), and Thomas Hill (1829-1908) were among its leaders. Williams was trained in New York and had studied in Rome before coming West. In 1874 he was hired as the director of the newly opened San Francisco Art Association School of Design. A well-loved and respected teacher, he trained a number of art students including the redoubtable Impressionist Guy Rose. Keith was a prolific painter, known as "California's Old Master" in his later years. He specialized in Barbizon-style pastorals and created dark and moody forest scenes. Hill is best known for his majestic views of Yosemite Valley, where he built a studio in 1883; he is credited with over 5,000 paintings of that locale. Like Williams, Keith and Hill were trained in academic, European styles and achieved maturity prior to the advent of Impressionism. These artists and others were entrenched in an artistic tradition that inhibited the establishment of the Impressionist aesthetic in San Francisco until well after the turn of the 20th century. As a result, many young artists who came to San Francisco looking for a place to settle turned their attention south.

The sunny Southern California climate has been offered as motivation for the advent of Impressionism in the South. The San Francisco earthquake of April 1906 was also a factor. However, the chief motivation was surely an economic one. Los Angeles did not have a substantial art establishment at the time, but became the alternative metropolitan center to which young artists flocked in California in the late 19th century. Those artists were essentially Impressionist painters.

In time a large group of artists settled in Southern California, and by 1915 the *plein-air* painters themselves had become the entrenched establishment with their coterie of dealers, patrons, and writers, who functioned as an impediment to the imminent generation of Modernist artists that followed World War 1. The 1930s heralded change. The Great Depression created hardships for all artists in California. Regionalism and Modernism made inroads. Modernists as well as *plein-air* artists joined in the Works Progress Administration programs, such as the Federal Arts Project, which allotted mural commissions in public buildings. Moreover, by the

Cat. No. 23 Armin Hansen (American, 1886-1957)
 The Farm House, 1915
 Oil on canvas
 30 x 36 inches
 The Irvine Museum,
 gift of James and Linda Ries

start of World War II, most of the prominent California Impressionists had died or withdrawn from the public eye. After the economic recovery, the style had become a nostalgic souvenir of a bygone era.

During the 1940s and 1950s the art of California was defined by the formidable presence of Millard Sheets (1907-1989) and his associates. His activities in the fields of art instruction, architecture, mural work, and above all watercolor painting with the California Water Color Society, marked an entire artistic generation with his imprimatur.

This same period denotes the "Babylonian Exile" of the *plein-air* mode, with only the smallest suggestion of public interest in the style. The major artists of the period, Guy Rose, Elmer Wachtel, Franz A. Bischoff (Cat. No. 3), Joseph Kleitsch, and

Cat. No. 3 Franz Bischoff (American, 1864-1929)
Untitled Coastal Seascape, n.d.
Oil on board
13 x 19 inches
Joan Irvine Smith Collection

Granville Redmond, died prior to the beginning of World War II. William Wendt (Cat. No. 57) and Alson S. Clark were largely inactive after 1941, Wendt having retired to his home in Laguna Beach, and Clark concentrating on murals, lithographs, and watercolors not in the Impressionist style.

Those paintings that had been sold during these masters' lifetimes remained on the walls of the original purchasers until the 1960s and 1970s, when indifferent heirs sold works which eventually found their way to local antique and art shops. Other works were sold by the artists' families. For example, promotion of Edgar Payne's legacy became the mission of his widow, Elsie Palmer Payne (1984-1971), who was a distinguished painter of the post-Depression American Scene. Mrs. Payne put aside her own work to memorialize her husband's art by holding many receptions, lec-

Cat. No. 57 William Wendt (American, 1865-1946)
Quiet Brook, 1923
Oil on canvas
30 x 36 inches
Joan Irvine Smith Fine Arts, Inc.

tures, and exhibitions in her studio-home and other locations throughout Southern California (Cat. No. 37).

Public collections, too, reached the resale market. In 1977 the Los Angeles County Museum of Art, at the time the greatest repository of works of this style, decided to sell the vast majority of its *plein-air* holdings at public auction. The museum's interests lay elsewhere, and the rationale for the sale was that these works were "no longer shown." The sale took place at Sotheby Parke Bernet, Los Angeles, November 7, 8, and 9, 1977. The auction's catalogue lists and illustrates a large variety of paintings, and, to this day, the sale remains the single most important group of California Impressionist paintings ever sold at auction. When the Pasadena Art Museum became the Norton Simon Museum, Sotheby Parke Bernet, Los Angeles, held another significant sale of California Impressionist paintings on March 17 and 18, 1980. That collection, assembled by Josephine P. Everett and others, represented a cross-section of many important artists that had been the pride of the Pasadena art community.

Although both of these important sales were disasters for public collections, they contributed to the renewal of interest in these artists. The immediate infusion of important works from these two museums, as well as others from private collections, into the art market of Los Angeles was directly responsible for the formation of important, new private collections of this style.

Fortunately, many public and semi-private collections compiled earlier in the century survived the 1970s. Notable among the public collections are those of the Museum of California/Oakland Museum, the Bowers Museum of Cultural Art in Santa Ana, and the Laguna Art Museum in Laguna Beach. Semi-private collections, like those of the California Club, the Jonathan Club, and the Los Angeles Athletic Club also have provided important venues for California Impressionism.

In 1972 Nancy Dustin Wall Moure, then assistant curator of American Art at the Los Angeles County Museum of Art, curated the first significant post-war exhibition devoted solely to California artists of the *plein-air* period. Held at the Pomona College Gallery in Claremont, California, *Los Angeles Painters of the Nineteen-Twenties* marked the first serious re-evaluation of these artists and their work in over 50 years.

The bibliography of California Impressionism also had lain dormant for about 50 years, with the last significant publications on these artists being the small-format exhibition books on Guy Rose, William Wendt, and Edgar Payne published by the Stendahl Galleries of Los Angeles in the mid-1920s, and the homage to Elmer Wachtel published by *Los Angeles Times* art critic Antony Anderson in 1930. In 1975 Nancy Moure privately published a three-volume set of her research on Southern Californian art: *The California Water Color Society: Prize Winners, 1931-1954*; *Index to Exhibitions 1921-1954*, *Artists' Clubs and Exhibitions in Los Angeles before 1930*; and *Dictionary of Art and Artists in Southern California before 1930*. The last volume, the dictionary, became an indispensable guide to the forgotten artists of this lively movement. With these books in hand, museums, art dealers, and private collectors finally had a concise source for biographical and exhibition information and thus an aid in determining the relative merits of these artists and their works.

The Monterey Peninsula Museum of Art mounted a noteworthy retrospective of the vigorous school of *plein-air* artists in their area in 1976, *Yesterday's Artists on the Monterey Peninsula* (Cat. No. 36). A concise and informative catalogue by Helen Spangenberg documented the show.

Cat. No. 37 Edgar Payne (American, 1882-1947)
 Untitled Seascape, n.d.
 Oil on canvas
 20 x 24 inches
 Joan Irvine Smith Collection

Cat. No. 36 Edgar Payne (American, 1882-1947)
 Sentinels of the Coast, Monterey, n.d.
 Oil on canvas
 28 x 34 inches
 The Irvine Museum

Fittingly, the first museum to mount a comprehensive retrospective exhibition of this period was the Laguna Beach Museum of Art (now called the Laguna Art Museum). The museum was founded in 1918 when artists of the Laguna Beach Art Association needed a site to exhibit their works. The members of the group pooled their efforts and completed a building which became the museum in 1929. In the summer of 1979, the Laguna Museum opened *Southern California Artists: 1890-1940*, organized by its director, Thomas K. Enman, and accompanied by a catalogue written by Nancy Moure.

Moure curated another significant exhibition the following year, *Painting and Sculpture in Los Angeles, 1900-1945*, at the Los Angeles County Museum of Art. Because the museum had sold much of its collection at auction only three years before, the majority of the pieces on display were borrowed from a growing list of private collectors in Southern California.

With the availability of a substantial number of paintings to the "secondary market" and the renewed scholarly interest in California Impressionists came a resurgence of commercial galleries dealing in the genre. In the 1920s there had been a large

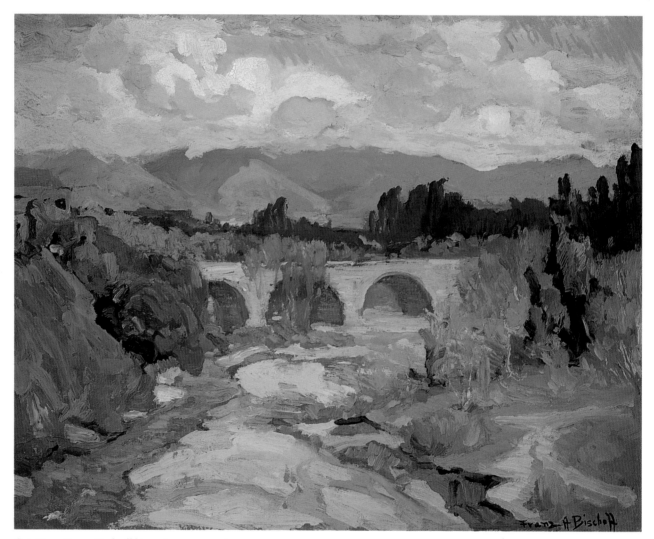

Cat. No. 4 Franz Bischoff (American, 1864-1929)
 Arroyo Seco, n.d.
 Oil on board
 13 x 16½ inches
 Joan Irvine Smith Fine Arts, Inc.

number of art galleries selling the works of the California Impressionists. Earl Stendahl, who founded the venerable Stendahl Galleries in 1921, was the principal dealer to most of the significant artists of the period. Faced with the continual decline in patronage for *plein-air* paintings, Stendahl changed the focus of the gallery in 1945 to pre-Columbian art. In 1923 a group of artists founded a cooperative gallery called the Biltmore Salon in the Biltmore Hotel in downtown Los Angeles. Over the years, the gallery changed names and ownership several times, finally becoming the Biltmore Gallery, selling contemporary paintings as well as occasional *plein-air* and Western masters until it moved to Scottsdale, Arizona, in the 1980s, when it turned exclusively to selling Western paintings (Cat. No. 4). The Poulsen Galleries, founded in Pasadena in 1927, continued to operate as a dealer in paintings through the post-war era and into the present with a large inventory of Californian paintings.

By the 1970s only a few commercial art galleries were actively selling California Impressionists' works. Two of the most prominent dealers from Los Angeles in the mid-1970s were Frank Leonard and Marian Bowater. Bowater handled several artists'

Cat. No. 52 Donna Schuster (American, 1883-1953)
Panama-Pacific International Exposition, Fine Arts Pavilion, 1916
Watercolor on paper
17 x 17 inches
The Redfern Gallery, Laguna Beach, California

estates, including a remarkable selection of paintings by Jean Mannheim (1862-1945); regrettably, her gallery did not document the estate with a catalogue. Specializing in contemporary paintings and graphics, the Redfern Gallery in the San Fernando Valley also featured a large group of paintings by Donna Schuster (Cat. No. 52), whose estate it acquired in 1975. In recent years the Redfern Gallery has actively promoted *plein-air* paintings from its location in Laguna Beach. While in law school in the mid-1970s, George Stern began his career as a private dealer specializing in Californian art. In 1980, he opened George Stern Fine Arts in Encino, and in 1994 the gallery moved to Melrose Avenue in West Hollywood. In the early 1970s DeWitt McCall opened a gallery in Bellflower that offered art restoration, framing, and paintings by California artists. Petersen Galleries, on Rodeo Drive in Beverly Hills, changed its emphasis to California Impressionist paintings in 1979. The first gallery to adopt a national image as a dealer in California *plein-air* art, it purchased several estates of California artists, held retrospective exhibitions, and published a series of catalogues and books to document the exhibitions. Among these are: *The Paintings of Franz A. Bischoff* (1980), *The Paintings of Sam Hyde Harris* (1980), *Alson S. Clark* (1983), *Christian Von Schneidau* (1986), and *Elsie Palmer Payne* (1990). In Santa Barbara, Gary Breitweiser, with Studio 2 Gallery, was an "early" proponent of California *plein-air* painting. In Northern California, Maxwell Galleries in San Francisco was the most prominent in the field. Each of these dealers has had a lasting effect on the genre, and all but Petersen Galleries are still active.

The Los Angeles County Museum auction in 1977 drew the avid attention of Dr. Irwin Schoen, one of the earliest private collectors who had renewed interest in California paintings. At its height, his collection included some of the most important works of the period, among them several paintings by Guy Rose, the best of which he purchased at the museum auction. Having no books to guide him, Schoen relied on his eye and his long experience in judging paintings.

Carl S. Dentzel, California cultural historian and director of the Southwest Museum in Highland Park, just north of Los Angeles, was another collector of paintings by California artists before the resurgence in their popularity began. Because the Southwest Museum's collections center on superb examples of cultural and ethnic artifacts relating to the American Southwest, California paintings were not often displayed there. Yet Dentzel's private collection was one of the strongest of its day. After his death his private collections, which also included many superb Asian and Southwestern artifacts, were divided among several museums, with the Laguna Art Museum receiving many of the paintings. Others remain with his widow, Elizabeth Waldo Dentzel.

The 1980s saw a growing interest in California *plein-air* paintings and the formation of many private collections, some of which are represented by paintings in this book. In 1982 Morton H. Fleischer, president of Franchise Finance Corporation of America in Scottsdale, began collecting California Impressionist paintings. First shown in the corporate offices, the Morton H. Fleischer F.F.C.A. Collection made its national debut in a major exhibition in 1988 at the Gilcrease Museum, in Tulsa, Oklahoma. The collections acquired by Fleischer and his wife formed the basis for the Fleischer Museum, an institution dedicated solely to California Impressionism in the new F.F.C.A. Building in Scottsdale in 1990.

In 1983, Gerald and Bente Buck, of Laguna Hills, began their extensive collection of California art. Building on the theme of California art of the 20th centu-

ry, the Buck Collection includes works on paper, sculpture, and decorative arts as well as paintings.

One of the most important collections of California *plein-air* art belongs to Thomas Stiles and his wife, Barbara Alexander, of New York City. Starting in 1984, Stiles, a Wall Street money manager, and his wife, an investment banker, have continually sought to refine their collection, which contains some of the best-known examples of the major artists of the period.

The Fieldstone Collection, which comprises a large selection of works dating from the turn of the century to the present, was begun in 1985 by Peter Ochs, founder of the Fieldstone Company, and is administered by Mary MacIntyre; this substantial corporate collection is housed in its corporate offices.

That same year, Jack and Suzie Kenefick started their small and highly personalized collection. Numbering fewer than 30 paintings, the Kenefick collection has shared exhibition venues with much larger collections throughout the country. Women artists of the period figure prominently in this collection.

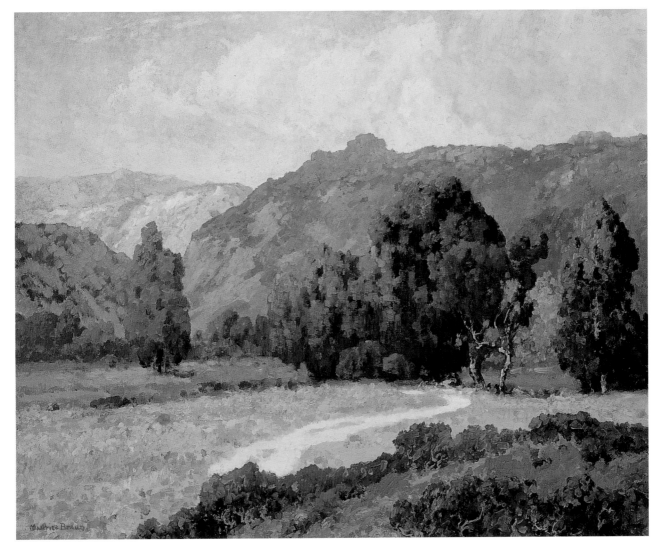

Cat. No. 6 Maurice Braun (American, 1877-1941)
 Road to the Canyon. n.d.
 Oil on canvas
 24 x 30 inches
 Joan Irvine Smith Fine Arts, Inc.

In 1982 Ruth Westphal published *Plein Air Painters of California: The Southland*, the first nationally distributed book that featured California *plein-air* artists. The success of this volume prompted the publication of *Plein Air Painters of California: The North*, in 1986 (Cat. No. 6).

The bibliography of California artists was greatly augmented in 1986 with the publication of *Artists in California 1786-1940*, by Edan M. Hughes. This useful book supplemented Moure's pioneering *Dictionary of Art and Artists in Southern California before 1930* by including over 150 artists from the entire state.

In 1986 the Laguna Art Museum (formerly the Laguna Beach Art Museum) mounted the noteworthy exhibition *Early Artists in Laguna Beach: The Impressionists*, curated by Janet Blake Dominik. The exhibition was accompanied by a comprehensive catalogue with a large number of color plates. Arguably the finest catalogue produced at the time, it quickly sold out. Four years later, Laguna presented another significant show, *California Light, 1900-1930*, curated by Patricia Trenton; again, the catalogue quickly sold out its initial printing.

By the start of the 1990s, California Impressionism had reached a level of general acceptance by museums, collectors, and art dealers throughout California. Important exhibitions of American art in other parts of the country also began to include a few examples of California *plein-air* painting as part of their offerings. In his seminal work published in 1990, *Art Across America*, William H. Gerdts devoted extensive sections to both Northern and Southern California.

The renaissance of the California *plein-air* style coincides with the revitalization of contemporary artistic interest in outdoor painting. Under the leadership of the California Art Club, founded in 1909 by the original *plein-air* painters, a growing number of artists are pursuing the same goals and approaches that motivated their predecessors nearly a hundred years ago.

The Irvine Museum was founded in 1992 by Joan Irvine Smith and her late mother, Athalie R. Clarke, and opened to the public on January 15, 1993. Since then, the museum has sponsored six traveling exhibitions, published as many catalogues, and joined in the production of two multi-part documentaries for public television. Simply stated, the mission of The Irvine Museum calls for the preservation and display of California Impressionist paintings. Their intrinsic, aesthetic beauty documents the beauty of California in a bygone era. They inspire a reverence and concern for our environment, and they call for the responsible development and use of our natural resources.

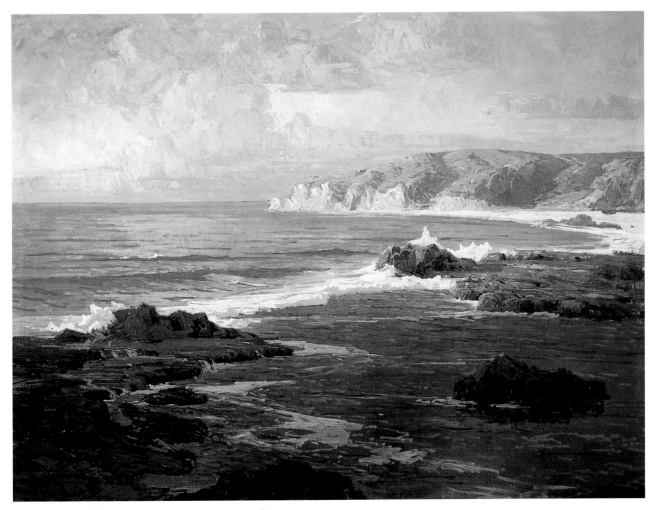

Cat. No. 53 Jack Wilkinson Smith (American, 1873-1949)
Crystal Cove State Park, n.d.
Oil on canvas
52 x 70 inches
Joan Irvine Smith Fine Arts, Inc.

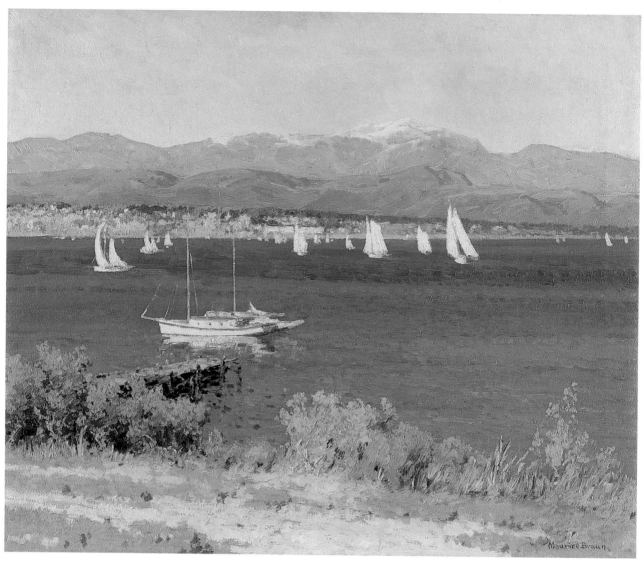

Cat. No. 5

Catalogue of the Exhibition

Cat. No. 1 Louis Betts (American, 1873-1961)
Mid-Winter, Coronado Beach, c. 1907
Oil on canvas
29 x 24 inches
The Irvine Museum

Cat. No. 2 Franz Bischoff (American, 1864-1929)
Roses, n.d.
Oil on canvas
30 x 40 inches
Joan Irvine Smith Collection

Cat. No. 3 Franz Bischoff (American, 1864-1929)
Untitled Coastal Seascape, n.d.
Oil on board
13 x 19 inches
Joan Irvine Smith Collection

Cat. No. 4 Franz Bischoff (American, 1864-1929)
Arroyo Seco, n.d.
Oil on board
13 x 16½ inches
Joan Irvine Smith Fine Arts, Inc.

Cat. No. 5 Maurice Braun (American, 1877-1941)
Glorietta Bay, San Diego, c. 1920
Oil on canvas
25 x 30 inches
Collection of Mr. and Mrs. Jack Kenefick

Cat. No. 6 Maurice Braun (American, 1877-1941)
Road to the Canyon, n.d.
Oil on canvas
24 x 30 inches
Joan Irvine Smith Fine Arts, Inc.

Cat. No. 7 Benjamin C. Brown (American, 1865-1942)
The Joyous Garden
Oil on canvas
30½ x 40½ inches
Joan Irvine Smith Fine Arts, Inc.

Cat. No. 8 Benjamin C. Brown (American, 1865-1942)
Pasadena, n.d.
Oil on canvas
14 x 10 inches
Private Collection

Cat. No. 9 William Vincent Cahill (American, 1878-1924)
Grandma's Gown, 1912
Oil on canvas
24½ x 20¼ inches
The Fleischer Museum

Cat. No. 10 William Merritt Chase (American, 1849-1916)
Monterey, California, 1914
Oil on panel
15 x 20 inches
Collection of The Oakland Museum of
California, gift by exchange through Maxwell
Galleries, Ltd.

Cat. No. 11 Alson Clark (American, 1876-1949)
Ruins of San Juan Capistrano, n.d.
Oil on board
31 x 25 inches
Joan Irvine Smith Fine Arts, Inc.

Cat. No. 12 Colin Campbell Cooper (American, 1856-1937)
Two Women, n.d.
Oil on board
24½ x 21½ inches
Joan Irvine Smith Fine Arts, Inc.

Cat. No. 13 Colin Campbell Cooper (American, 1856-1937)
Pergola at Samarkand Hotel, Santa Barbara, c. 1921
Oil on canvas
29 x 36 inches
Joan Irvine Smith Fine Arts, Inc.

Cat. No. 14 Colin Campbell Cooper (American, 1856-1937)
Cottage Interior, n.d.
Oil on canvas
20 x 24 inches
The Henderson Collection

Cat. No. 15 Frank Cuprien (American, 1871-1948)
A Summer Evening, n.d.
Oil on canvas
11 x 17 inches
Joan Irvine Smith Fine Arts, Inc.

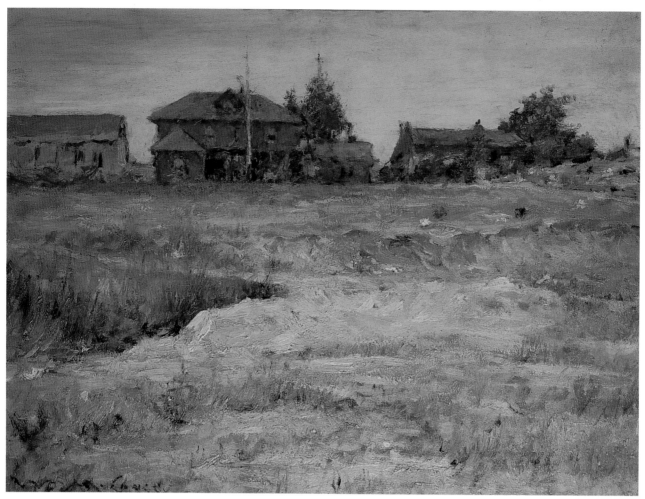

Cat. No. 10

Cat. No. 16 Paul Dougherty (American, 1877-1947)
The Twisted Ledge, n.d.
Oil on canvas
34 x 36 inches
Joan Irvine Smith Fine Arts, Inc.

Cat. No. 17 E. Charlton Fortune (American, 1885-1969)
Summer, 1914
Oil on canvas
22¼ x 26 inches
The Fine Arts Museums of San Francisco,
museum purchase, Skae Fund Legacy

Cat. No. 18 E. Charlton Fortune (American, 1885-1969)
The Cabbage Patch, c. 1914
Oil on canvas
20 x 24 inches
Collection of Patricia and John Dilks

Cat. No. 19 John Frost (American, 1890-1937)
The Pool at Sundown, n.d.
Oil on panel
24 x 28 inches
Joan Irvine Smith Fine Arts, Inc.

Cat. No. 20 John Gamble (American, 1863-1957)
Joyous Spring, n.d.
Oil on canvas
26 x 20 inches
Joan Irvine Smith Fine Arts, Inc.

Cat. No. 21 Seldon Connor Gile (American, 1877-1947)
Boat and Yellow Hills, n.d.
Oil on canvas
30½ x 36 inches
Collection of The Oakland Museum of California, gift of Dr. and Mr. Frederick Novy, Jr.

Cat. No. 17

Cat. No. 19

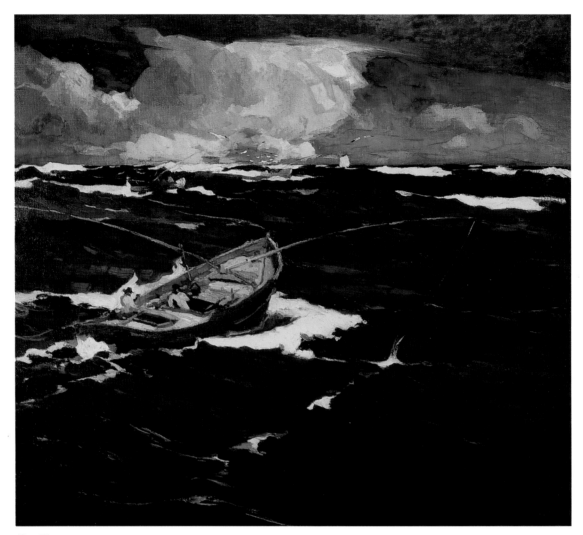

Cat. No. 25

Cat. No. 22 Paul Grimm (American, 1892-1974)
 Eucalyptus and Clouds, n.d.
 Oil on canvas
 25 x 30 inches
 Joan Irvine Smith Fine Arts, Inc.

Cat. No. 23 Armin Hansen (American, 1886-1957)
 The Farm House, 1915
 Oil on canvas
 30 x 36 inches
 The Irvine Museum, gift of
 James and Linda Ries

Cat. No. 24 Armin Hansen (American, 1886-1957)
 Making Port, n.d.
 Oil on canvas
 30 x 32 inches
 Joan Irvine Smith Collection

Cat. No. 25 Armin Hansen (American, 1886-1957)
 Salmon Trawlers, 1918
 Oil on canvas
 47⅛ x 53½ inches
 Monterey Peninsula Museum of Art,
 gift of Jane and Justin Dart

Cat. No. 26 Sam Hyde Harris (American, 1889-1977)
 Todd Shipyards, San Pedro, n.d.
 Oil on canvas
 20 x 23 inches
 Joan Irvine Smith Collection

Cat. No. 27 Childe Hassam (American, 1859-1935)
 Point Lobos, Carmel, 1914
 Oil on canvas
 28⁵⁄₁₆ x 36³⁄₁₆ inches
 Los Angeles County Museum of Art,
 Mr. and Mrs. William Preston Harrison Collection

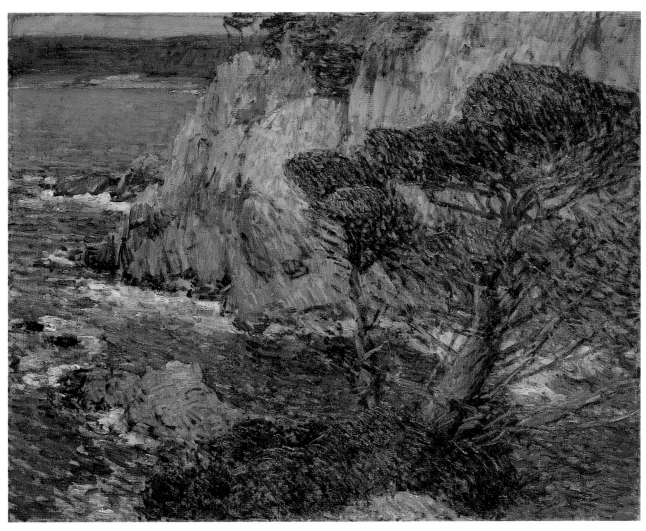

Cat. No. 27

Cat. No. 28 Childe Hassam (American, 1859-1935)
The Silver Veil and the Golden Gate, 1914
Oil on canvas
30 x 32 inches
Valpariso University Art Gallery
and Collections, Sloan Collection

Cat. No. 29 Anna Hills (American, 1882-1930)
July Afternoon, Laguna Beach, 1915
Oil on canvas
7 x 10 inches
The Redfern Gallery, Laguna Beach, California

Cat. No. 30 William Lees Judson (American, 1842-1928)
Arroyo Seco with Bridge, n.d.
Oil on board
18 x 30 inches
Joan Irvine Smith Fine Arts, Inc.

Cat. No. 31 Joseph Kleitsch (American, 1886-1931)
The Oriental Shop, n.d.
Oil on canvas
32 x 26 inches
Joan Irvine Smith Fine Arts, Inc.

Cat. No. 32 Joseph Kleitsch (American, 1886-1931)
The Old Post Office, 1922
Oil on canvas
40 x 30 inches
Laguna Art Museum,
gift of Mrs. Joseph Kleitsch

Cat. No. 33 Mary DeNeale Morgan (American, 1868-1948)
Cypress at Monterey, n.d.
Watercolor and gouache on paper
18½ x 24½ inches
Joan Irvine Smith Fine Arts, Inc.

Cat. No. 34 Ernest Bruce Nelson (American, 1888-1952)
Pacific Grove Shoreline, c. 1915
Oil on canvas
24 x 30 inches
Collection of Patricia and John Dilks

Cat. No. 35 Edgar Payne (American, 1882-1947)
Sierra Divide, 1921
Oil on canvas
24 x 28 inches
Joan Irvine Smith Fine Arts, Inc.

Cat. No. 36 Edgar Payne (American, 1882-1947)
Sentinels of the Coast, Monterey, n.d.
Oil on canvas
28 x 34 inches
The Irvine Museum

Cat. No. 37 Edgar Payne (American, 1882-1947)
Untitled Seascape, n.d.
Oil on canvas
20 x 24 inches
Joan Irvine Smith Collection

Cat. No. 38 Hanson Puthuff (American, 1875-1972)
Transient Shadows, c. 1926
Oil on canvas
26 x 30 inches
The Buck Collection

Cat. No. 39 Joseph Raphael (American, 1869-1950)
Tea in the Orchard, c. 1916
Oil on canvas
39 x 46¾ inches
Collection of John Garzoli

Cat. No. 40 Granville Redmond (American, 1871-1935)
Flowers Under the Oaks, n.d.
Oil on canvas
20 x 25 inches
Joan Irvine Smith Collection

Cat. No. 41 Granville Redmond (American, 1871-1935)
Silver and Gold, c. 1918
Oil on canvas
30 x 40 inches
Laguna Art Museum,
gift of Mr. and Mrs. J.G. Redmond

Cat. No. 42 John Hubbard Rich (American, 1878-1955)
The Idle Hour, 1917
Oil on canvas
14 x 14 inches
The Irvine Museum

Cat. No. 43 Arthur G. Rider (American, 1886-1976)
The Spanish Boat, n.d.
Oil on canvas
35 x 41 inches
Joan Irvine Smith Fine Arts, Inc.

Cat. No. 44 William Ritschel (American, 1864-1949)
Northern California Coastal Scene, n.d.
Oil on board
20 x 24 inches
Joan Irvine Smith Fine Arts, Inc.

Cat. No. 45 William Ritschel (American, 1864-1949)
Mammoth Cove, n. d.
Oil on canvas
50¼ x 60½ inches
Monterey Peninsula Museum of Art,
gift of the Ritschel Memorial Trust

Cat. No. 46 Guy Rose (American, 1867-1925)
The Green Parasol, c. 1909
Oil on canvas
31 x 19 inches
Collection of Patricia and John Dilks

Cat. No. 47 Guy Rose (American, 1867-1925)
San Gabriel Road, c. 1914
Oil on canvas
24 x 29 inches
Joan Irvine Smith Fine Arts, Inc.

Cat. No. 48 Guy Rose (American, 1867-1925)
Point Lobos, n.d.
Oil on canvas
24 x 29 inches
Joan Irvine Smith Fine Arts, Inc.

Cat. No. 49 Guy Rose (American, 1867-1925)
The Model, c. 1919
Oil on canvas
24 x 20 inches
The Buck Collection

Cat. No. 50 Guy Rose (American, 1867-1925)
The Oak, c. 1916
Oil on canvas
30 x 28 inches
The Gianetto Collection

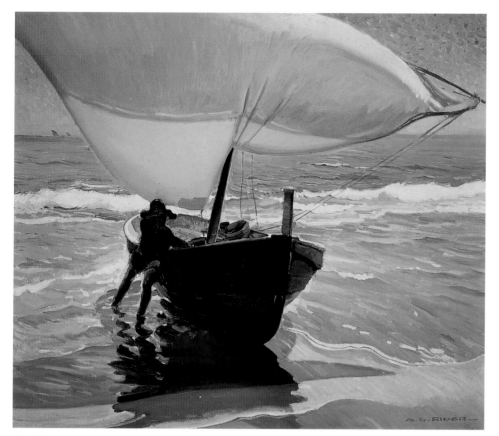

Cat. No. 43

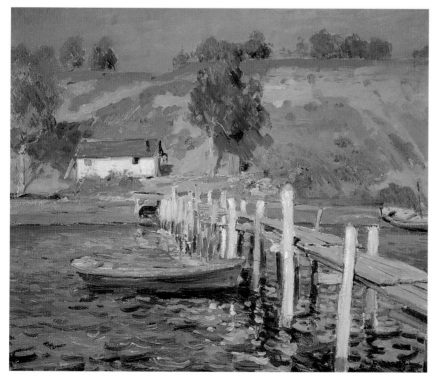

Cat. No. 44

Cat. No. 51 Donna Schuster (American, 1883-1953)
 Girl in a Hammock, 1917
 Oil on canvas
 29½ x 29½ inches
 The Redfern Gallery,
 Laguna Beach, California

Cat. No. 52 Donna Schuster (American, 1883-1953)
 Panama-Pacific International Exposition,
 Fine Arts Pavilion, 1916
 Watercolor on paper
 17 x 17 inches
 The Redfern Gallery,
 Laguna Beach, California

Cat. No. 53 Jack Wilkinson Smith (American, 1873-1949)
 Crystal Cove State Park, n.d.
 Oil on canvas
 52 x 70 inches
 Joan Irvine Smith Fine Arts, Inc.

Cat. No. 54 Elmer Wachtel (American, 1864-1929)
 Golden Autumn, Cajon Pass, n.d.
 Oil on canvas
 22 x 30 inches
 Joan Irvine Smith Fine Arts, Inc.

Cat. No. 55 Marion Kavanagh Wachtel (American, 1876-1954)
 Untitled Landscape, n.d.
 Watercolor and pastel on paper
 15½ x 19½ inches
 Joan Irvine Smith Fine Arts, Inc.

Cat. No. 56 Marion Kavanagh Wachtel (American, 1876-1954)
 Enchanted Isle, n.d.
 Watercolor on paper
 23½ x 31¾ inches (sight)
 The Fieldstone Collection

Cat. No. 57 William Wendt (American, 1865-1946)
 Quiet Brook, 1923
 Oil on canvas
 30 x 36 inches
 Joan Irvine Smith Fine Arts, Inc.

Cat. No. 58 William Wendt (American, 1865-1946)
 Untitled Landscape, n.d.
 Oil on canvas
 25 x 30 inches
 Joan Irvine Smith Fine Arts, Inc.

Cat. No. 59 William Wendt (American, 1865-1946)
 Where Nature's God Hath Wrought, 1925
 Oil on canvas
 50⁵⁄₁₆ x 60¹⁄₁₆ inches
 Los Angeles County Museum of Art,
 Mr. and Mrs. Alan C. Balch Collection

Cat. No. 59

Cat. No. 51

Selected Bibliography

Books and Exhibition Catalogues

A Century of California Painting, 1870-1970. Introduction by Kent L. Seavey and essays by Joseph Armstrong Baird, Jr., Paul Mills, Mary Fuller McChesney, and Alfred Frankenstein. Los Angeles: Crocker Citizens Bank, 1970.

Anderson, Antony. *Elmer Wachtel: A Brief Biography*. Los Angeles: Carl A. Bundy Quill & Press, 1930.

Anderson, Timothy J., Eudorah M. Moore, and Robert W. Winter, eds. *California Design 1910*. 1974; rpt. Santa Barbara, California, and Salt Lake City: Gibbs Smith, Publisher, 1980.

Art in California: A Survey of American Art with Special Reference to California Painting, Sculpture and Architecture, Past and Present, Particularly as Those Arts were Represented at the Panama-Pacific International Exposition. Essays by Bruce Porter *et al.* San Francisco: R. L. Bernier Publisher, 1916; rpt., Irvine, California: Wesphal Publishing, 1988.

Baird, Joseph Armstrong, Jr., ed. *From Exposition to Exposition: Progressive and Conservative Northern California Painting, 1915-1939*. Sacramento: Crocker Art Museum, 1981.

Baird, Joseph Armstrong, Jr. and Ellen Schwartz. *Northern California Art: An Interpretive Bibliography to 1915*. Davis, California: Library Associates, University Library, University of California, 1977.

Bartlett, Dana W. *The Bush Aflame*. Los Angeles: Dana Bartlett, 1923.

Boas, Nancy. *The Society of Six: California Colorists*. San Francisco: Bedford Arts, Publishers, 1988.

Brinton, Christian. *Impressions of the Art at the Panama-Pacific Exposition*. New York: John Lane Company, 1916.

Carmel Art Association. *Our First Five National Academicians: The Carmel Art Association Presents an Exhibition of Works by Paul Dougherty, Arthur Hill Gilbert, Armin Hansen, William Ritschel, Howard E. Smith*. Introduction by Gael Donovan. Carmel, California: Carmel Art Association, 1989.

——————. *Six Early Women Artists: A Diversity of Style: Rowena Meeks Abdy, Jeannette Maxfield Lewis, Eunice Cashion MacLennan, Laura Wasson Maxwell, M. Evelyn McCormick, Mary DeNeale Morgan*. Carmel, California: Carmel Art Association, 1991.

Chelette, Iona M., Katherine Plake Hough, and Will South. *California Grandeur and Genre: From the Collection of James L. Coran and Walter A. Nelson-Rees*. Palm Springs, California: Palm Springs Desert Museum, 1991.

Coen, Rena Neumann. *The Paynes, Edgar & Elsie, American Artists*. Minneapolis: Payne Studios Inc., 1988.

Dominik, Janet Blake. *Early Artists in Laguna Beach: The Impressionists*. Laguna Beach, California: Laguna Art Museum, 1986.

The Dorian Society. *Kern County Collects: The California Landscape*. Bakersfield, California: California State University, 1990.

The Downey Museum of Art. *Donna Norine Schuster: 1883-1953*. Essay by Leonard R. de Grassi. Downey, California: The Downey Museum of Art, 1977.

Franchise Finance Corporation of America. *Masterworks of California Impressionism: The FFCA, Morton H. Fleischer Collection*. Foreword by Morton H. Fleischer and essay by Jean Stern. Phoenix: Franchise Finance Corporation of America, 1987 (second edition).

Glenn, Constance W. and Sue Taylor-Winter. *In Praise of Nature: The Landscapes of William Wendt*. Long Beach, California: University Art Museum, California State University, 1989.

Hailey, Gene, ed. *California Art Research: Biography and Works*. 20 vols. San Francisco: Works Progress Administration, 1937.

Hansen, Esther, ed. *The Official Guide and Descriptive Book of the Panama-California International Exposition*. San Diego, California: National Views, (1916?).

Hatfield, Dalzell. *Joseph Kleitsch and His Work*. Los Angeles: The Stendahl-Hatfield Art Galleries, 1928.

Hughes, Edan Milton. *Artists in California, 1786-1940*. San Francisco: Hughes Publishing Company, 1986.

The Irvine Museum. *Romance of the Bells: The California Missions in Art*. Essays by Jean Stern, Gerald J. Miller, Pamela Hallan-Gibson, and Norman Neuerburg. Irvine, California: The Irvine Museum, 1995.

James, George Wharton. *Exposition Memories, Panama-California Exposition, San Diego, 1916*. Pasadena: The Radiant Life Press, 1917.

Kammerling, Bruce. *100 Years of Art in San Diego: Selections from the Collection of the San Diego Historical Society*. San Diego: San Diego Historical Society, 1991.

Kanst Art Gallery. *Exhibition of Paintings by Maurice Braun*. Los Angeles: The Kanst Art Gallery, 1917.

Laguna Art Museum. *75 Works, 75 Years: Collecting the Art of California*. Laguna Beach, California: Laguna Art Museum, 1993.

Laguna Art Museum. *Southern California Artists 1890-1940*. Introduction by Maudette W. Ball. Laguna Beach, California: Laguna Art Museum, 1979.

————. *Virginia Steele Scott Memorial Collection and Examples from the Permanent Collection.* Laguna Beach, California: Laguna Art Museum, 1980.

Louise Whitford Gallery. *The Plein Air Tradition.* London: Louise Whitford Gallery, 1982.

Los Angeles County Museum of Art. *Painting and Sculpture in Los Angeles 1900-1945.* Los Angeles: Los Angeles County Museum of Art, 1980.

McGlynn, Betty Hoag, *Carmel Art Association: A History.* Carmel, California: Carmel Art Association, 1987.

Monterey Peninsula Museum of Art. *Armin Hansen: The Jane and Justin Dart Collection.* Introduction by Jo Farb Hernandez and essays by Anthony R. White and Charlotte Berney. Monterey, California: Monterey Peninsula Museum of Art, 1993.

————. *Colors and Impressions: The Early Work of E. Charlton Fortune.* Introduction by Jo Farb Hernandez and essays by Robert E. Brennan and Merle Shipper. Monterey, California: Monterey Peninsula Museum of Art, 1990.

Moure, Nancy Dustin Wall. *Artists' Clubs and Exhibitions in Los Angeles Before 1930.* Glendale, California: Dustin Publications, 1975.

————. *Dictionary of Art and Artists in Southern California Before 1930.* Glendale, California: Dustin Publications, 1975.

————. *Painting and Sculpture in Los Angeles, 1900-1945.* Los Angeles: Los Angeles County Museum of Art, 1980.

————. *Publications in Southern California Art, Number 3.* Glendale, California: Dustin Publications, 1975.

————. *William Wendt, 1865-1946.* Laguna Beach, California: Laguna Art Museum, 1977.

————. *Exhibition of Selected Honor Paintings from the Palace of Fine Arts, Panama-Pacific International Exposition, San Francisco.* San Francisco, 1916.

Nash, Steven A. *Facing Eden: 100 Years of Landscape Art in the Bay Area.* Introduction by Steven A. Nash and essays by Michael R. Corbett, Nancy Boas and Marc Simpson, Patricia Junker, Steven A. Nash, Constance Lewallen, Bill Berkson, and Ellen Manchester. San Francisco and Berkeley: The Fine Arts Museums of San Francisco and University of California Press, 1995.

Nelson-Rees, Walter and James Coran. *If Pictures Could Talk: Stories about California Paintings in Our Collection.* Oakland: WIM, 1989.

Neuhaus, Eugen. *The Galleries of the Exposition: A Critical Review of the Paintings, Statuary, and the Graphic Arts in the Palace of Fine Arts at the Panama-Pacific International Exposition.* San Francisco: Paul Elder and Company Publishers, 1915.

—————. *Painters, Pictures and the People*. San Francisco: Philopolis Press, 1918.

The Oakland Museum. *Granville Redmond*. Introduction by Harvey L. Jones and essay by Mary Jean Haley. Oakland, California: The Oakland Museum, 1989.

—————. *Impressionism: The California View*. Introduction by Harvey L. Jones and essays by John Caldwell and Terry St. John. Oakland, California: The Oakland Museum, 1981.

Orr-Cahall, Christina, ed. *The Art of California: Selected Works from the Collection of The Oakland Museum*. Introduction by Christina Orr-Cahall and essays by Harvey L. Jones, Terry St. John, Therese Thau Heyman, Hazel V. Bray, and Christina OrrCahall. Oakland and San Francisco: The Oakland Museum and Chronicle Books, 1984.

Payne, Edgar A. *Composition of Outdoor Painting*. Hollywood: Seward Publishing Company, 1941.

Petersen, Martin E. *Second Nature: Four Early San Diego Landscape Painters*. Foreword by Everett Gee Jackson. Munich and San Diego: Prestel-Verlag and San Diego Museum of Art, 1991.

Pomona College Gallery. *Los Angeles Painters of the Nineteen-Twenties*. Claremont, California: Pomona College Gallery 1972.

Puthuff, Hanson and Louise Puthuff. *Hanson Duvall Puthuff, The Artist, The Man, 1875-1972*. Costa Mesa, California: The Spencer Printing Service, 1974.

San Francisco Institute of Art. *Exhibition of Paintings by Joseph Raphael*. San Francisco: San Francisco Institute of Art, 1910.

Singer Museum. *Joseph Raphael: 1869-1950*. Laren, New Hampshire: Singer Museum 1981.

South, Will. *Guy Rose: American Impressionist*. Introduction by William H. Gerdts and essays by Jean Stern and Will South. Oakland and Irvine, California: The Oakland Museum and The Irvine Museum, 1995.

Spangenberg, Helen. *Yesterday's Artists on the Monterey Peninsula*. Monterey, California: Monterey Peninsula Museum of Art, 1976.

St. John, Terry. *Society of Six*. Oakland, California: The Oakland Museum, 1972.

Stendahl Art Galleries. *Catalogue of the Guy Rose Memorial*. Essays by Peyton Boswell and Anderson Anderson. Los Angeles: Stendahl Art Galleries, 1926.

—————. *Edgar Alwyn Payne and his Work*. Essays by Antony Anderson and Fred S. Hogue. Los Angeles: Stendahl Art Galleries, 1926.

—————. *Exhibition of Paintings by Joseph Kleitsch*. Los Angeles: Stendahl Art Galleries, 1928.

—————. *Guy Rose, Paintings of France and America*. Essays by Antony Anderson and Earl Stendahl. Los Angeles: Stendahl Art Galleries, 1922.

—————. *William Wendt and His Work*. Los Angeles: Stendahl Art Galleries, 1926.

Stendahl, Earl L. *Guy Rose: A Biographical Sketch and Appreciation*. Los Angeles: Ackerman Press, 1922.

Stern, Jean. *Alson S. Clark*. Los Angeles: Petersen Publishing Company, 1983.

—————. *American Impressionism, California School: Selections from the Permanent Collection and Loans from the Paul and Kathleen Bagley Collection*. Phoenix: FFCA Publishing Company, 1989.

—————. *American Impressionism: A California Collage*. Scottsdale, Arizona: FFCA Publishing Company and Fleischer Museum, 1991.

—————. *The Paintings of Franz A. Bischoff*. Los Angeles: Petersen Publishing Company, 1980.

Stern, Jean and Joan Irvine Smith. *Reflections of California: The Athalie Richardson Irvine Clarke Memorial Exhibition*. Irvine, California: The Irvine Museum, 1994.

Stern, Jean, Janet Blake Dominik and Harvey L. Jones. *Selections from The Irvine Museum*. Irvine, California: The Irvine Museum, 1992.

Stern, Jean and Ruth Westphal. *The Paintings of Sam Hyde Harris, 1889-1977: A Retrospective Exhibition*. Los Angeles: Petersen Publishing Company, 1981.

Thurston, J. S. *Laguna Beach of Early Days*. Culver City, California: Press of Murry and Gee, 1947.

Trask, John E. D. and J. Nilsen Laurvik, eds. *Catalogue De Luxe of the Department of Fine Arts, Panama-Pacific International Exposition*. 2 vols. San Francisco: Paul Elder and Company, 1915.

Trenton, Patricia and William H. Gerdts. *California Light 1900-1930*. Essays by Michael P. McManus, William H. Gerdts, Bram Dijkstra, Iris H. W. Engstrand, Joachim Smith, Ilene Susan Fort, Jean Stern, Patricia Trenton, and Janet Blake Dominik. Laguna Beach, California: Laguna Art Museum, 1991 (second edition).

Walker, John Alan. *Documents on the Life and Art of William Wendt (1865-1946), California's Laureate of the Paysage Moralisé*. Big Pine, California: John Alan Walker, Bookseller, 1992.

Westphal, Ruth Lilly. *Plein Air Painters of California: The Southland*. Essays by Terry DeLapp, Thomas Kenneth Enman, Nancy Dustin Wall Moure, Martin E. Petersen, and Jean Stern. Irvine, California: Westphal Publishing, 1982.

—————, ed. *Plein Air Painters of California: The North*. Essays by Janet Blake Dominik, Harvey L. Jones, Betty Hoag McGlynn, Paul Chadbourne Mills, Martin E. Petersen, Terry St. John, Jean Stern, Jeffrey Stewart, and Raymond L. Wilson. Irvine, California: Westphal Publishing, 1986.

Articles and Reviews

"The Art of Joseph Kleitsch." *Fine Arts Journal* 36 (June 1919): 46-52.

Berry, Rose V. S. "California and Some California Painters." *American Magazine of Art* 15 (June 1924): 279-91.

——————. "A Painter of California." (Guy Rose) *International Studio* 80 (January 1925): 332-37.

——————. "A Patriarch of Pasadena." (Benjamin Brown) *International Studio* 81 (May 1925): 123-26.

Boyer, Hazel. "A Notable San Diego Painter." (Maurice Braun) *California Southland* 6 (April 1924): 12.

Brown, Benjamin. "The Beginnings of Art in Los Angeles." *California Southland* 6 (January 1924): 7-8.

"California as a Sketching Ground." *International Studio* 43 (April 1911): 121-31.

"California Artists." *Pictorial California and the Pacific* 5 (May 1930): 18-19.

Comstock, Helen. "Painter of East and West." (Maurice Braun) *International Studio* 80 (March 1925): 485-88.

Downes, William H. "California for the Landscape Painter." *American Magazine of Art* 11 (December 1920): 491-502.

Gearhart, Edna. "Benjamin Brown of Pasadena." *Overland Monthly* 82 (July 1924): 214-16.

Handley, Marie Louise. "Gardner Symons — Optimist." *The Outlook* (27 December 1913): 881-87.

Fred Hogue. "The God of the Mountains." (Edgar Payne) *Los Angeles Times*, 22 May 1927.

——————. "A Hungarian Artist." (Joseph Kleitsch) *Los Angeles Times*, 25 June 1928.

Laurvik, J. Nilsen. "Art in California: The San Francisco Art Association's Annual Exhibition." *American Magazine of Art* 9 (May 1918): 275-80.

Leeper, John Palmer. "Alson S. Clark, 1876-1949." *Pasadena Art Institute Bulletin* 1 (April 1951): 15-19.

Marquis, Neeta. "Jack Wilkinson Smith, Colourist." *International Studio* 69 (December 1919): 74-76.

Maxwell, Everett Carroll. "Jack Wilkinson Smith — Constructive Artist." *Overland Monthly* 90 (October 1932): 237-38.

—————————. "Painters of the West — Hanson Puthuff." *Progressive Arizona* 6 (September 1931): 10-11.

Millier, Arthur. "Growth of Art in California," in Frank J. Taylor, *Land of Homes*. Los Angeles: Powell Publishing Company, 1929.

—————————. "Our Artists in Person." (Anna Hills) *Los Angeles Times*, 7 June 1931.

—————————. "Our Artists in Person." (Benjamin Brown) *Los Angeles Times*, 19 October 1920.

—————————. "Our Artists in Person." (Hanson Puthuff) *Los Angeles Times*, 21 September 1930.

—————————. "Our Artists in Person." (Granville Redmond) *Los Angeles Times*, 22 March 1931.

—————————. "Our Artists in Person." (Jack Wilkinson Smith) *Los Angeles Times*, 5 October 1930.

—————————. "Our Artists in Person." (William Wendt) *Los Angeles Times*, 6 July 1930.

—————————. "William Ritschel and Others in the South." *The Argus* 4 (March 1929): 5.

Miner, Frederick R. "California the Landscapist Land of Heart's Desire." *Western Art* (June-August 1914): 31-34.

Parkhurst, Thomas Shrewsbury. "Gardner Symons — Painter and Philosopher." *Fine Arts Journal* 33 (November 1916): 556-65.

Petersen, Martin E. "Maurice Braun: Master Painter of the California Landscape." *Journal of San Diego History* 23 (Summer 1977): 20-33.

Ryan, Beatrice Judd. "The Rise of Modern Art in the Bay Area." *California Historical Society Quarterly* 38 (March 1959): 1-5.

Seares, Mabel Urmy. "California as a Sketching Ground." *International Studio* 43 (April 1911): 121-31.

—————————. "A California School of Painters." *California Southland* 3 (February 1921): 10-11.

—————————. "California as Presented by Her Artists." *California Southland* 6 (June 1924): 7-13.

—————————. "William Wendt." *American Magazine of Art* 7 (April 1916): 232-35.

"Wachtel and His Work." *Land of Sunshine* 4 (March 1896): 168-72.

Walker, John Alan. "William Wendt, 1865-1946." *Southwest Art* 2 (June 1974): 42-45.

Wilson, L. W. "Santa Barbara's Artist Colony." *American Magazine of Art* 12 (December 1921): 411-14.

Wortz, Melinda. "Celebrating the Feminine Palette." (Anna Hills) *Los Angeles Times*, 31 January 1977.

Pig Pig Rides

Pig Pig Rides

by David McPhail

E. P. Dutton New York

for cousin Mark

Unicorn is a registered trademark of E. P. Dutton.
Library of Congress number 82-9777
ISBN 0-525-44222-7
Published in the United States by E. P. Dutton,
2 Park Avenue, New York, N.Y. 10016
Published simultaneously in Canada by
Fitzhenry & Whiteside Limited, Toronto
Editor: Emilie McLeod Designer: Isabel Warren-Lynch
Printed in Hong Kong by South China Printing Co.
First Unicorn Edition 1985 COBE
10 9 8 7 6 5 4 3 2 1

Pig Pig and his mother were eating breakfast.

"What are you doing today?" asked Pig Pig's mother.

"Well," said Pig Pig,

"I've got some stuff to deliver."

"That's nice," said his mother.

"Then I'll take my racing car and try for a speed record."

"Ummm," said his mother.

"I'll jump 500 elephants on my motorcycle."

"And then?" said his mother.

"Then I'll race my horse at Rocking Ham Park!"

"Oh?" said his mother.

"And I'll drive a train
all the way to China."

"Would you pick up a loaf of bread?"

"And when I'm back, I might even drive a rocket
to the moon. I'm off!" said Pig Pig.

"You will be back before dark?"

"Please be careful."

"Why?" asked Pig Pig.

"Because I love you," said his mother.